Slideguide

Gardner's Art through the Ages
The Western Perspective

FOURTEENTH EDITION

Volume II

Fred S. Kleiner

 WADSWORTH
CENGAGE Learning·

Australia • Brazil • Japan • Korea • Mexico • Singapore • Spain • United Kingdom • United States

WADSWORTH
CENGAGE Learning·

For product information and technology assistance, contact us at
**Cengage Learning Customer & Sales Support,
1-800-354-9706**

For permission to use material from this text or product, submit all requests online at **www.cengage.com/permissions**
Further permissions questions can be emailed to
permissionrequest@cengage.com

ISBN-13: 978-1-285-16741-1
ISBN-10: 1-285-16741-4

Wadsworth
20 Channel Center Street
Boston, MA 02210
USA

Cengage Learning is a leading provider of customized learning solutions with office locations around the globe, including Singapore, the United Kingdom, Australia, Mexico, Brazil, and Japan. Locate your local office at:
www.cengage.com/global

Cengage Learning products are represented in Canada by Nelson Education, Ltd.

To learn more about Wadsworth, visit
www.cengage.com/wadsworth

Purchase any of our products at your local college store or at our preferred online store
www.cengagebrain.com

Printed in the United States of America
1 2 3 4 5 6 7 16 15 14 13 12

Contents

Chapter 14

Late Medieval Italy

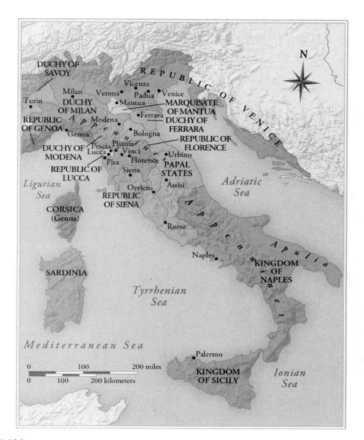

MAP 14-1 Italy around 1400.

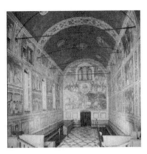

FIG. 14-01 Giotto di Bondone, interior of the Arena Chapel (Cappella Scrovegni; looking west), Padua, Italy, 1305–1306.

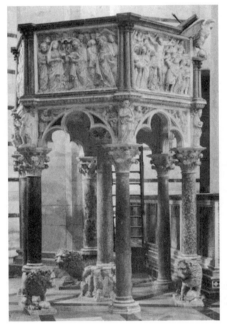

FIG. 14-02 Nicola Pisano, pulpit of the baptistery, Pisa, Italy, 1259–1260. Marble, 15′ high.

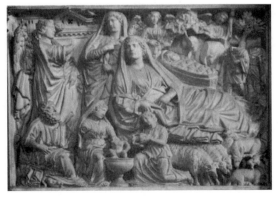

FIG. 14-03 Nicola Pisano, *Annunciation, Nativity,* and *Adoration of the Shepherds*, relief panel on the baptistery pulpit, Pisa, Italy, 1259–1260. Marble, 2′ 10″ × 3′ 9″.

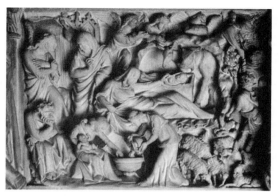

FIG. 14-04 GIOVANNI PISANO, *Annunciation, Nativity,* and *Adoration of the Shepherds*, relief panel on the pulpit of Sant'Andrea, Pistoia, Italy, 1297–1301. Marble, 2′ 10″ × 3′ 4″.

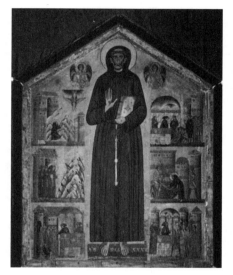

FIG. 14-05 BONAVENTURA BERLINGHIERI, *Saint Francis Altarpiece*, San Francesco, Pescia, Italy, 1235. Tempera on wood, 5′ × 3′ × 6′.

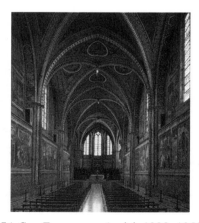

FIG. 14-05A San Francesco, Assisi, 1228–1253.

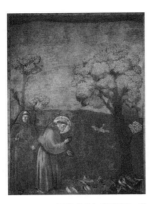

FIG. 14-05B ST. FRANCIS MASTER, *Preaching to the Birds*, ca. 1290–1300.

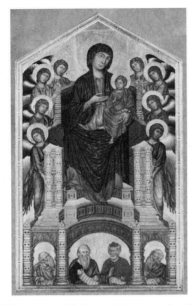

FIG. 14-06 CIMABUE, *Madonna Enthroned with Angels and Prophets*, from Santa Trinità, Florence, ca. 1280–1290. Tempera and gold leaf on wood, 12′ 7″ × 7′ 4″. Galleria degli Uffizi, Florence.

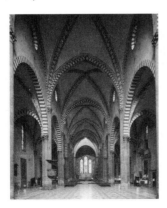

FIG. 14-06A Santa Maria Novella, Florence, begun ca. 1246.

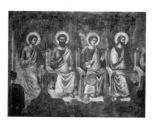

FIG. 14-06B CAVALLINI, *Last Judgment*, ca. 1290–1295.

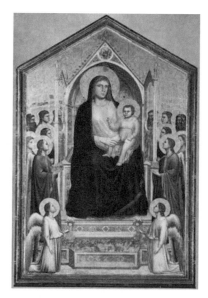

FIG. 14-07 GIOTTO DI BONDONE, *Madonna Enthroned*, from the Church of Ognissanti, Florence, ca. 1310. Tempera and gold leaf on wood, 10′ 8″ × 6′ 8″. Galleria degli Uffizi, Florence.

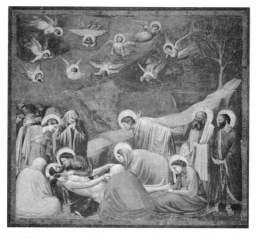

FIG. 14-08 GIOTTO DI BONDONE, *Lamentation*, Arena Chapel (Cappela Scrovegni), Padua, Italy, ca. 1305. Fresco, 6′ 6 3/4″ × 6′ 3/4″.

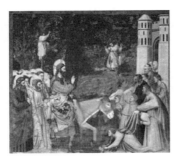

FIG. 14-08A GIOTTO, *Entry into Jerusalem*, ca. 1305.

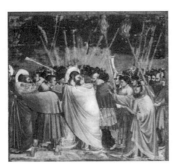

FIG. 14-08B GIOTTO, *Betrayal of Jesus*, ca. 1305.

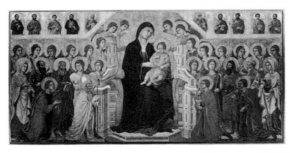

FIG. 14-09 DUCCIO DI BUONINSEGNA, *Virgin and Child Enthroned with Saints*, principal panel of the *Maestà* altarpiece, from Siena Cathedral, Siena, Italy, 1308–1311. Tempera and gold leaf on wood 7′ × 13′. Museo dell'Opera del Duomo, Siena.

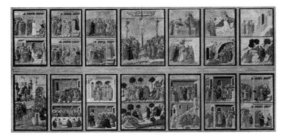

FIG. 14-10 DUCCIO DI BUONINSEGNA, *Life of Jesus*, 14 panels from the back of the *Maestà* altarpiece, from Siena Cathedral, Siena, Italy, 1308–1311. Tempera and gold leaf on wood 7′ × 13′. Museo dell'Opera del Duomo, Siena.

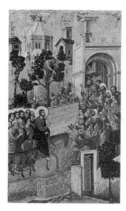

FIG. 14-10A DUCCIO, *Entry into Jerusalem*, 1308–1311.

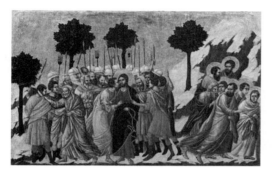

FIG. 14-11 DUCCIO DI BUONINSEGNA, *Betrayal of Jesus*, panel on the back of the *Maestà* altarpiece, from Siena Cathedral, Siena, Italy, 1309–1311. Tempera and gold leaf on wood, 1′ 10 1/2″ × 3′ 4″. Museo dell'Opera del Duomo, Siena.

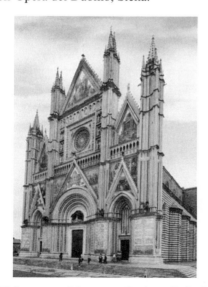

FIG. 14-12 LORENZO MAITANI, Orvieto Cathedral (looking northeast), Orvieto, Italy, begun 1310.

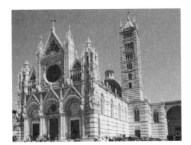

FIG. 14-12A Siena Cathedral, begun ca. 1226.

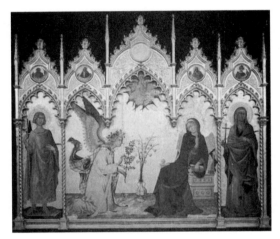

FIG. 14-13 SIMONE MARTINI and LIPPO MEMMI, *Annunciation* altarpiece, from Siena Cathedral, 1333 (frame reconstructed in the 19th century). Tempera and gold leaf on wood, center panel 10′ 1″ × 8′ 8 3/4″. Galleria degli Uffizi, Florence.

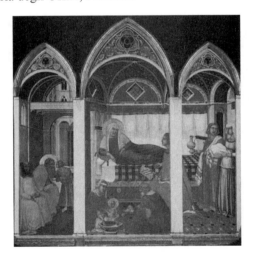

FIG. 14-14 PIETRO LORENZETTI, *Birth of the Virgin*, from the altar of Saint Savinus, Siena Cathedral, Siena, Italy, 1342. Tempera on wood, 6′ 1″ × 5′ 11″. Museo dell'Opera del Duomo, Siena.

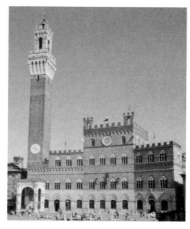

FIG. 14-15 Palazzo Pubblico (looking east), Siena, Italy, 1288–1309.

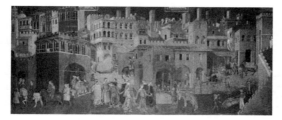

FIG. 14-16 AMBROGIO LORENZETTI, *Peaceful City*, detail from *Effects of Good Government in the City and in the Country*, east wall, Sala della Pace, Palazzo Pubblico, Siena, Italy, 1338–1339. Fresco.

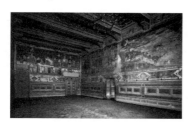

FIG. 14-16A SALA DELLA PACE, Siena, 1338–1339.

FIG. 14-17 AMBROGIO LORENZETTI, *Peaceful Country*, detail from *Effects of Good Government in the City and in the Country*, east wall, Sala della Pace (FIG. 14-16A), Palazzo Pubblico (FIG. 14-15), Siena, Italy, 1338–1339. Fresco.

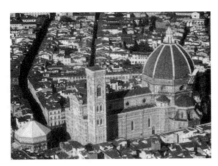

FIG. 14-18 ARNOLFO DI CAMBIO and others, aerial view of Santa Maria del Fiore (and the Baptistery of San Giovanni; looking northeast), Florence, Italy, begun 1296. Campanile designed by GIOTTO DI BONDONE, 1334.

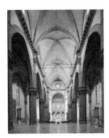

FIG. 14-18A Nave, Florence Cathedral, begun 1296.

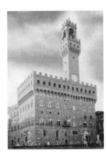

FIG. 14-18B Palazzo della Signoria, Florence, 1299–1310.

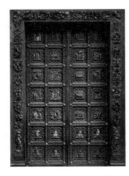

FIG. 14-19 ANDREA PISANO, south doors of the Baptistery of San Giovanni (FIG. 12-27), Florence, Italy, 1330–1336. Gilded bronze, doors 16′ × 9′ 2″; individual panels 1′ 7 1/4″ × 1′ 5″. (The door frames date to the mid-15th century.)

FIG. 14-19A ORCAGNA, Or San Michele tabernacle, 1355–1359.

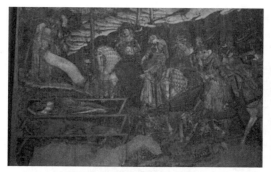

FIG. 14-20 FRANCESCO TRAINI or BUONAMICO BUFFALMACCO, two details of *Triumph of Death*, 1330s. Full fresco, 18′ 6″ × 49′ 2″. Camposanto, Pisa.

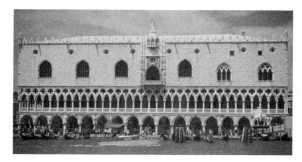

FIG. 14-21 Doge's Palace, Venice, Italy, begun ca. 1340–1345; expanded and remodeled, 1424–1438.

Chapter 15

Late Medieval and Early Renaissance Northern Europe

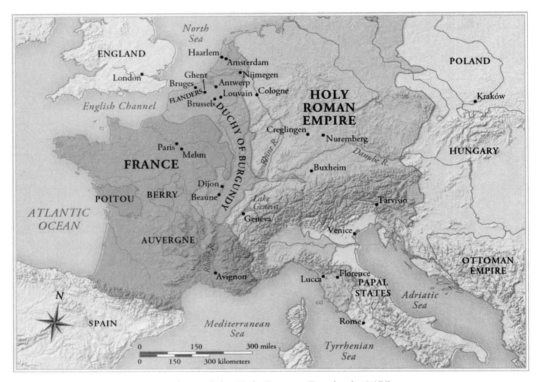

MAP 15-1 France, the duchy of Burgundy, and the Holy Roman Empire in 1477.

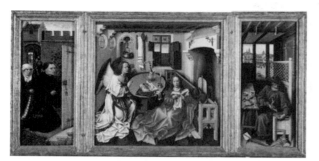

FIG. 15-01 ROBERT CAMPIN (Master of Flémalle), *Mérode Altarpiece* (open), ca. 1425–1428. Oil on wood, center panel 2′ 1 3/8″ × 2′ 7/8″, each wing 2′ 1 3/8″ × 10 7/8″. Metropolitan Museum of Art, New York (The Cloisters Collection, 1956).

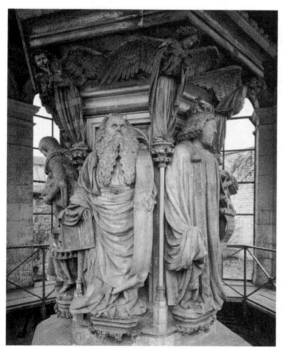

FIG. 15-02 CLAUS SLUTER, *Well of Moses*, Chartreuse de Champmol, Dijon, France, 1395–1406. Limestone, painted and gilded by JEAN MALOUEL, Moses 6′ high.

FIG. 15-02A SLUTER, Charteuse de Champmol portal, 1385–1393.

FIG. 15-03 MELCHIOR BROEDERLAM, *Retable de Champmol*, from the chapel of the Chartreuse de Champmol, Dijon, France, installed 1399. Oil on wood, each wing 5′ 5 3/4″ × 4′ 1 1/4″. Musée des Beaux-Arts, Dijon.

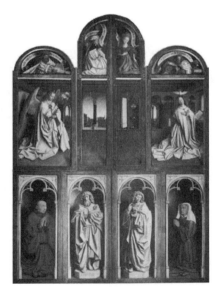

FIG. 15-04 HUBERT and JAN VAN EYCK, *Ghent Altarpiece* (closed), Saint Bavo Cathedral, Ghent, Belgium, completed 1432. Oil on wood, 11′ 5″ × 7′ 6″.

14

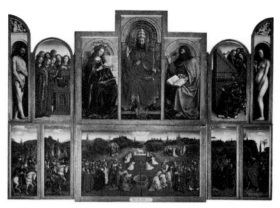

FIG. 15-05 HUBERT and JAN VAN EYCK, *Ghent Altarpiece* (open), Saint Bavo Cathedral, Ghent, Belgium, completed 1432. Oil on wood, 119 5″ × 15′ 1″.

FIG. 15-05A VAN EYCK, *Madonna in a Church*, ca. 1425–1430.

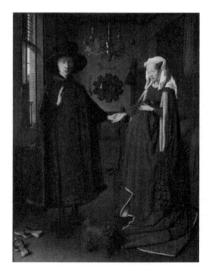

FIG. 15-06 JAN VAN EYCK, *Giovanni Arnolfini and His Wife*, 1434. Oil on wood, 2′ 9″ × 1′ 10 1/2″. National Gallery, London.

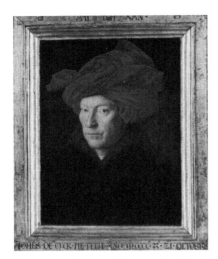

FIG. 15-07 JAN VAN EYCK, *Man in a Red Turban*, 1433. Oil on wood, 1′ 1 1/8″ × 10 1/4″. National Gallery, London.

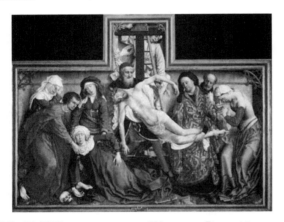

FIG. 15-08 ROGIER VAN DER WEYDEN, *Deposition*, center panel of a triptych from Notre-Dame hors-les-murs, Louvain, Belgium, ca. 1435. Oil on wood, 7′ 2 5/8″ × 8′ 7 1/8″. Museo del Prado, Madrid.

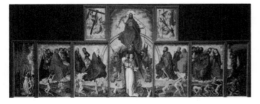

FIG. 15-08A VAN DER WEYDEN, *Last Judgment Alterpiece*, ca. 1444–1448.

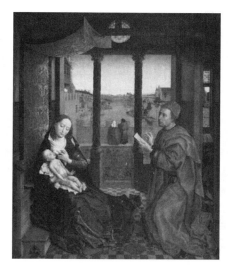

FIG. 15-09 ROGIER VAN DER WEYDEN, *Saint Luke Drawing the Virgin*, ca. 1435–1440. Oil and tempera on wood, 4′ 6 1/8″ × 3′ 7 5/8″. Museum of Fine Arts, Boston (gift of Mr. and Mrs. Henry Lee Higginson).

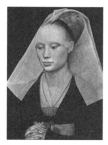

FIG. 15-09A VAN DER WEYDEN, *Portrait of a Lady*, ca. 1460.

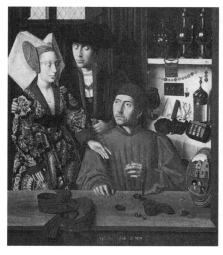

FIG. 15-10 PETRUS CHRISTUS, *A Goldsmith in His Shop*, 1449. Oil on wood, 3′ 3″ × 2′ 10″. Metropolitan Museum of Art, New York (Robert Lehman Collection, 1975).

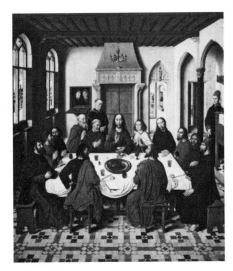

FIG. 15-11 DIRK BOUTS, *Last Supper*, center panel of the *Altarpiece of the Holy Sacrament*, Saint Peter's, Louvain, Belgium, 1464–1468. Oil on wood, 6′ × 5′.

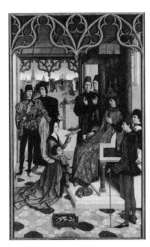

FIG. 15-11A BOUTS, *Justice of Otto III*, ca. 1470–1475.

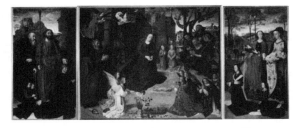

FIG. 15-12 HUGO VAN DER GOES, *Portinari Altarpiece* (open), from Sant'Egidio, Florence, Italy, ca. 1476. Tempera and oil on wood, center panel 8′ 3 1/2″ × 10′, each wing 8′ 3 1/2″ × 4′ 7 1/2″. Galleria degli Uffizi, Florence.

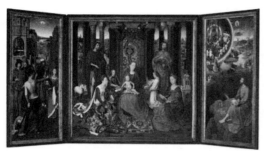

FIG. 15-13 HANS MEMLING, *Virgin with Saints and Angels*, center panel of the *Saint John Altarpiece*, Hospitaal Sint Jan, Bruges, Belgium, 1479. Oil on wood, center panel 5′ 7 3/4″ × 5′ 7 3/4″, each wing 5′ 7 3/4″ × 2′ 7 1/8″.

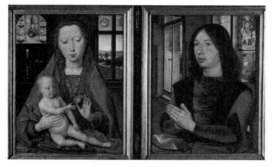

FIG. 15-14 HANS MEMLING, *Diptych of Martin van Nieuwenhove*, 1487. Oil on wood, each panel 1′ 5 3/8″ × 1′ 1″. Memlingmuseum, Bruges.

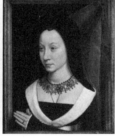

FIG. 15-14A MEMLING, *Tommaso Portinari*, and *Maria Baroncelli*, ca. 1470.

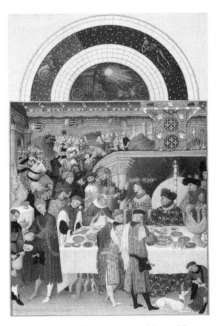

FIG. 15-15 LIMBOURG BROTHERS (POL, HERMAN, JEAN), *January*, from *Les Très Riches Heures du Duc de Berry*, 1413–1416. Colors and ink on vellum, 8 7/8″ × 5 3/8″. Musée Condé, Chantilly.

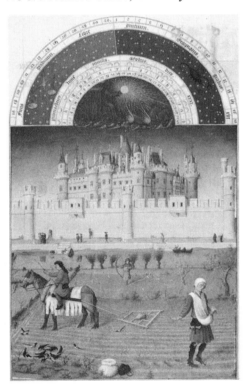

FIG. 15-16 LIMBOURG BROTHERS (POL, HERMAN, JEAN), *October*, from *Les Très Riches Heures du Duc de Berry*, 1413–1416. Colors and ink on vellum, 8 7/8″ × 5 3/8″. Musée Condé, Chantilly.

20

FIG. 15-16A *Hours of Mary of Burgundy*, ca. 1480.

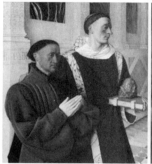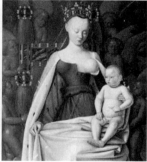

FIG. 15-17 JEAN FOUQUET, *Melun Diptych.* Left wing: *Étienne Chevalier and Saint Stephen*, ca. 1450. Oil on wood, 3′ 1/2″ × 2′ 9 1/2″. Gemäldegalerie, Staatliche Museen zu Berlin, Berlin. Right wing: *Virgin and Child*, ca. 1451. Oil on wood, 3′ 1 1/4″ × 2′ 9 1/2″. Koninklijk Museum voor Schone Kunsten, Antwerp.

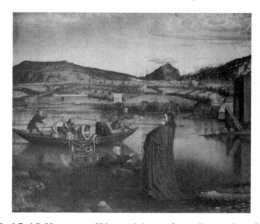

FIG. 15-18 KONRAD WITZ, *Miraculous Draught of Fish*, exterior wing of *Alterpiece of Saint Peter*, from the Chapel of Notre-Dame des Maccabées, Cathedral of Saint Peter, Geneva, Switzerland, 1444. Oil on wood, 4′ 3″ × 5′ 1″. Musée d'Art et d'Histoire, Geneva.

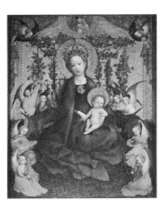

FIG. 15-18A Lochner, Madonna in the Rose Garden, ca. 1440.

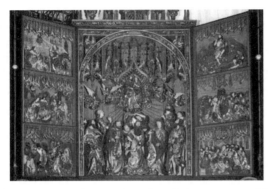

FIG. 15-19 Veit Sross, *Death and Assumption of the Virgin* (wings open), altar of the Virgin Mary, church of Saint Mary, Kraków, Poland, 1477–1489. Painted and gilded wood, center panel 23′9″ high.

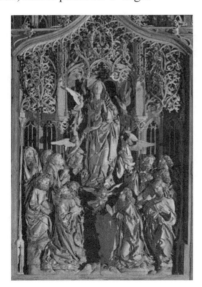

FIG. 15-20 Tilman Riemenschneider, *Assumption of the Virgin*, center panel of *Creglingen Altarpiece*, parish church, Creglingen, Germany, ca. 1495–1499. Lindenwood, 6′ 1″ wide.

FIG. 15-20A *Buxheim Saint Christopher*, 1423.

FIG. 15-21 MICHEL WOLGEMUT and shop, *Radeburga* page from the *Nuremberg Chronicle*, 1493. Woodcut. Printed by ANTON KOBERGER.

FIG. 15-22 MARTIN SCHONGAUER, *Saint Anthony Tormented by Demons*, ca. 1480–1490. Engraving, 1′ 1/4″ × 9″. Fondazione Magnani Rocca, Corte di Mamiano.

Chapter 16

The Renaissance in Quattrocento Italy

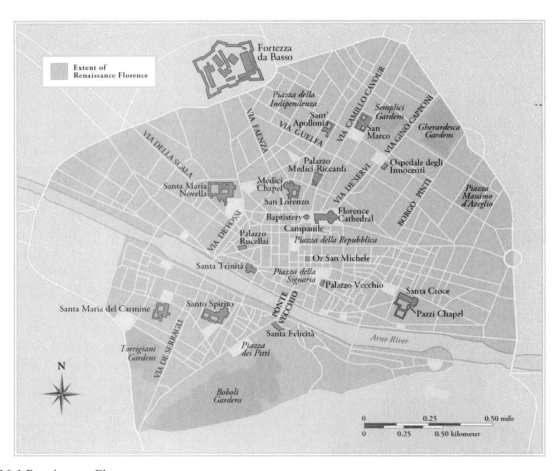

MAP 16-1 Renaissance Florence.

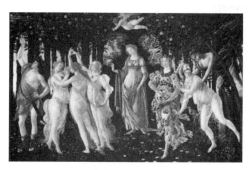

FIG. 16-01 Sandro Botticelli, *Primavera*, ca. 1482. Tempera on wood, 6′8″ × 10′4″. Galleria degli Uffizi, Florence.

FIG. 16-02 Filippo Brunelleschi, *Sacrifice of Isaac*, competition panel for east doors of the Baptistery of San Giovanni, Florence, Italy, 1401–1402. Gilded bronze, 1′ 9″ × 1′ 5 1/2″. Museo Nazionale del Bargello, Florence.

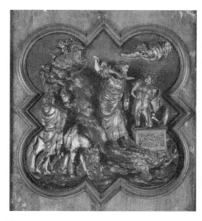

FIG. 16-03 Lorenzo Ghiberti, *Sacrifice of Isaac*, competition panel for east doors of the Baptistery of San Giovanni, Florence, Italy, 1401–1402. Gilded bronze, 1 9″ × 1′ 5 1/2″. Museo Nazionale del Bargello, Florence.

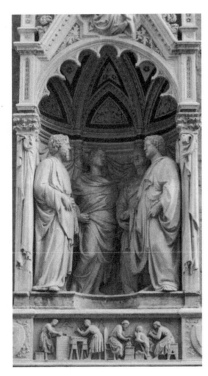

FIG. 16-04 NANNI DI BANCO, *Four Crowned Saints*,
Or San Michele, Florence, Italy, ca. 1410–1416.
Marble, figures 6′ high. Modern copy in exterior niche.
Original sculpture in museum on second floor of Or
San Michele, Florence.

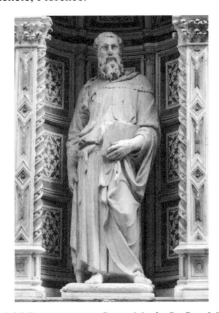

FIG. 16-05 DONATELLO, *Saint Mark*, Or San Michele,
Florence, Italy, ca. 1411–1413. Marble, figure 7′ 9″
high. Modern copy in exterior niche. Original sculpture
in museum on second floor of Or San Michele,
Florence.

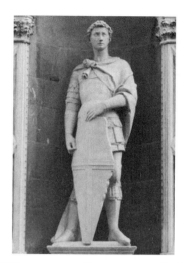

FIG. 16-06 Donatello, *Saint George*, Or San Michele, Florence, Italy, ca. 1410–1415. Marble, figure 6′ 10″ high. Modern copy in exterior niche. Original statue in Museo Nazionale del Bargello, Florence.

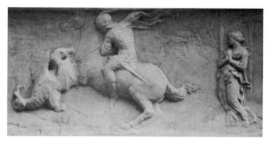

FIG. 16-07 Donatello, *Saint George and the Dragon*, relief below the statue of Saint George (FIG. 16-6), Or San Michele, Florence, Italy, ca. 1417. Marble, 1′ 3 1/4″ × 3′ 11 1/4″. Modern copy on exterior of Or San Michele. Original relief in Museo Nazionale del Bargello, Florence.

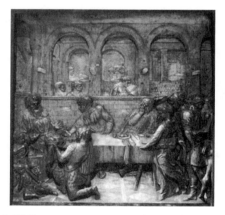

FIG. 16-08 Donatello, *Feast of Herod*, panel on the baptismal font of Siena Cathedral, Siena, Italy, 1423–1427. Gilded bronze, 1′ 11 1/2″ × 1′ 11 1/2″.

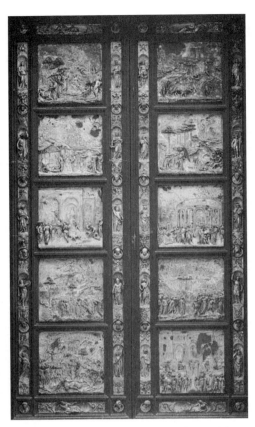

FIG. 16-09 LORENZO GHIBERTI, east doors (*Gates of Paradise*), Baptistery of San Giovanni, Florence, Italy, 1425–1452. Gilded bronze, 17′ high. Modern replica, 1990. Original panels in Museo dell'Opera del Duomo, Florence.

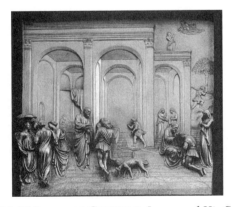

FIG. 16-10 LORENZO GHIBERTI, *Isaac and His Sons* (detail of FIG. 16-9), east doors (*Gates of Paradise*), Baptistery of San Giovanni, Florence, Italy, 1425–1452. Gilded bronze, 2′ 7 1/2″ × 2′ 7 1/2″. Museo dell'Opera del Duomo, Florence.

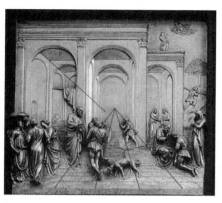

FIG. 16-11 Perspective diagram of FIG. 16-10.

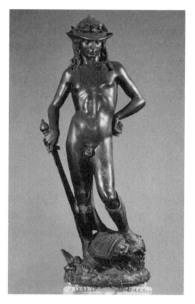

FIG. 16-12 DONATELLO, *David*, ca. 1440–1460. Bronze, 5′ 2 1/4″ high. Museo Nazionale del Bargello, Florence.

FIG. 16-12A DONATELLO, *Penitent Mary Magdalene*, ca. 1455.

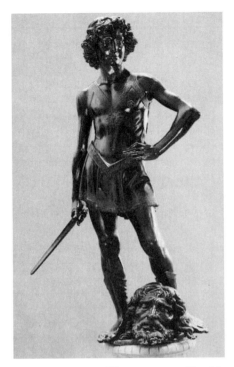

FIG. 16-13 ANDREA DEL VERROCCHIO, *David*, ca. 1465–1470. Bronze, 4′ 1 1/2″ high. Museo Nazionale del Bargello, Florence.

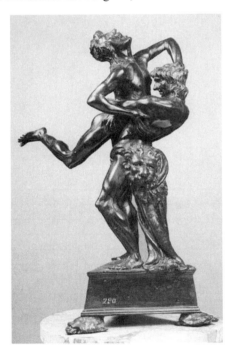

FIG. 16-14 ANTONIO DEL POLLAIUOLO, *Hercules and Antaeus*, ca. 1470–1475. Bronze, 1′ 6″ high with base. Museo Nazionale del Bargello, Florence.

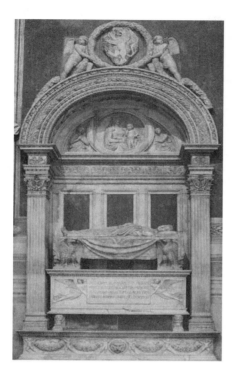

FIG. 16-15 BERNARDO ROSSELLINO, tomb of
Leonardo Bruni, Santa Croce, Florence, Italy,
ca. 1444–1450. Marble, 23′3 1/2″ high.

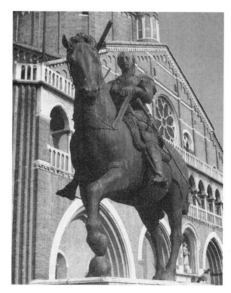

FIG. 16-16 DONATELLO, *Gattamelata* (equestrian
statue of Erasmo da Narni), Piazza del Santo, Padua,
Italy, ca. 1445–1453. Bronze, 12′ 2″ high.

31

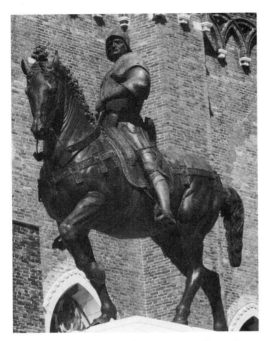

FIG. 16-17 ANDREA DEL VERROCCHIO, *Bartolommeo Colleoni* (equestrian statue), Campo dei Santi Giovanni e Paolo, Venice, Italy, ca. 1481–1496. Bronze, 13′ high.

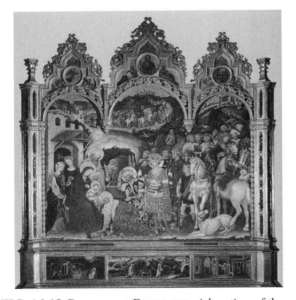

FIG. 16-18 GENTILE DA FABRIANO, *Adoration of the Magi*, altarpiece from the Strozzi chapel, Santa Trinità, Florence, Italy, 1423. Tempera on wood, 9′ 11″ × 9′ 3″. Galleria degli Uffizi, Florence.

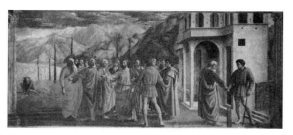

FIG. 16-19 MASACCIO, *Tribute Money*, Brancacci chapel, Santa Maria del Carmine, Florence, Italy, ca. 1424–1427. Fresco, 8′ 4 1/8″ × 19′ 7 1/8″.

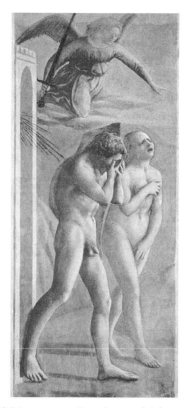

FIG. 16-20 MASACCIO, *Expulsion of Adam and Eve from Eden*, Brancacci chapel, Santa Maria del Carmine, Florence, Italy, ca. 1424–1427. Fresco, 7′ × 2′ 11″.

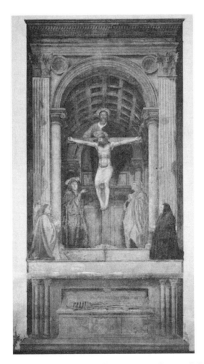

FIG. 16-21 MASACCIO, *Holy Trinity*, Santa Maria Novella, Florence, Italy, ca. 1424–1427. Fresco, 21′ 10 5/8″ × 10′ 4 3/4″.

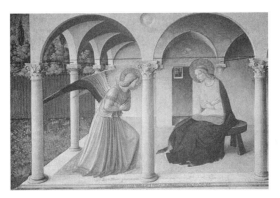

FIG. 16-22 FRA ANGELICO, *Annunciation*, San Marco, Florence, Italy, ca. 1438–1447. Fresco, 7′ 1″ × 10′ 6″.

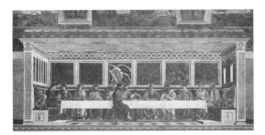

FIG. 16-23 ANDREA DEL CASTAGNO, *Last Supper*, refectory of the convent of Sant'Apollonia, Florence, Italy, 1447. Fresco, 15′ 5″ × 32′.

34

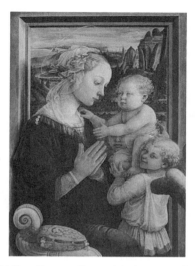

FIG. 16-24 FRA FILIPPO LIPPI, *Madonna and Child with Angels*, ca. 1460–1465. Tempera on wood, 2′ 11 1/2″ × 2′ 1″. Galleria degli Uffizi, Florence.

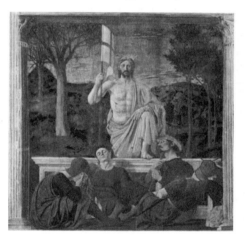

FIG. 16-25 PIERO DELLA FRANCESCA, *Resurrection*, Palazzo Communale, Borgo San Seplcro, Italy, ca. 1463–1465. Fresco, 7′4 5/8″ × 6′1/4″.

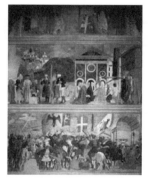

FIG. 16-25A PIERO DELLA FRANCESCA, *Legend of the True Cross*, ca. 1450–1445.

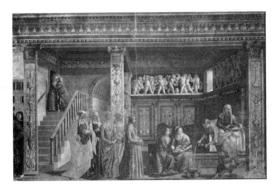

FIG. 16-26 DOMENICO GHIRLANDAIO, *Birth of the Virgin*, Cappella Maggiore, Santa Maria Novella, Florence, Italy, ca. 1485–1490. Fresco, 24′ 4″ × 14′ 9″.

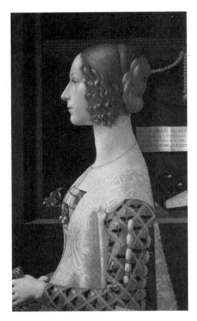

FIG. 16-27 DOMENICO GHIRLANDAIO, *Giovanna Tornabuoni*(?), 1488. Oil and tempera on wood, 2′ 6″ × 1′ 8″. Museo Thyssen-Bornemisza, Madrid.

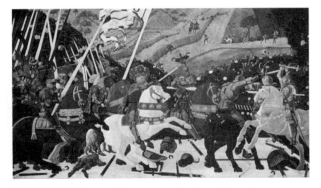

FIG. 16-28 PAOLO UCCELLO, *Battle of San Romano*, ca. 1435 or ca. 1455. Tempera on wood, 6′ × 10′ 5″. National Gallery, London.

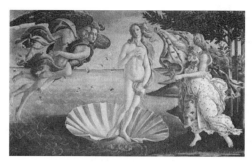

FIG. 16-29 SANDRO BOTTICELLI, *Birth of Venus*, ca. 1484–1486. Tempera on canvas, 5′ 9″ × 9′ 2″. Galleria degli Uffizi, Florence.

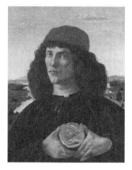

FIG. 16-29A Botticelli, *Young Man Holding a Medal*, ca. 1474–1475.

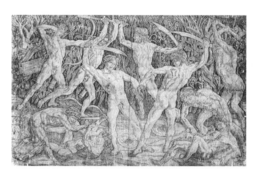

FIG. 16-30 ANTONIO DEL POLLAIUOLO, *Battle of Ten Nudes*, ca. 1465. Engraving, 1′ 3 1/8″ × 1′ 11 1/4″. Metropolitan Museum of Art, New York (bequest of Joseph Pulitzer, 1917).

FIG. 16-30A BRUNELLESCHI, Florence Cathedral dome, 1420–1436.

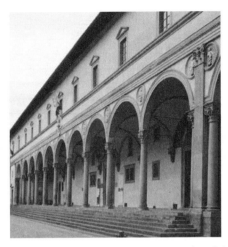

FIG. 16-31 FILIPPO BRUNELLESCHI, Loggia of the Ospedale degli Innocenti (Foundling Hospital; looking northeast), Florence, Italy, begun 1419.

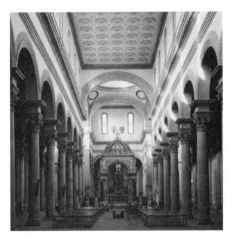

FIG. 16-32 FILIPPO BRUNELLESCHI, interior of Santo Spirito (looking northeast), Florence, Italy, designed 1434–1436; begun 1446.

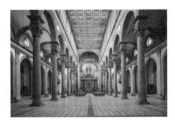

FIG. 16-32A BRUNELLISCHI, San Lorenzo, ca. 1421–1469.

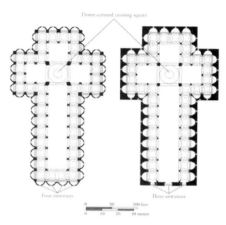

FIG. 16-33 FILIPPO BRUNELLESCHI, early plan (*left*) and plan as constructed (*right*) of Santo Spirito, Florence, Italy, designed 1434–1436; begun 1446.

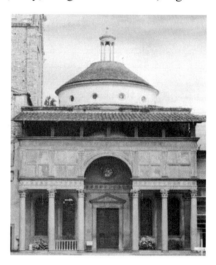

FIG. 16-34 FILIPPO BRUNELLESCHI, facade of the Pazzi Chapel, Santa Croce, Florence, Italy, begun 1433.

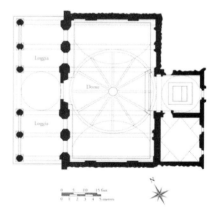

FIG. 16-35 FILIPPO BRUNELLESCHI, plan of the Pazzi Chapel, Santa Croce, Florence, Italy, begun 1433.

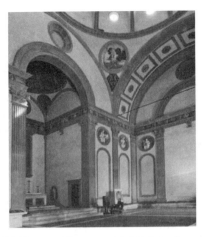

FIG. 16-36 FILIPPO BRUNELLESCHI, interior of the Pazzi Chapel (looking northeast), Santa Croce, Florence, Italy, begun 1433.

FIG. 16-36A LUCA DELLA ROBBIA, *Madonna and Child*, ca. 1455–1460.

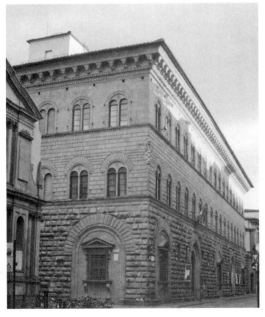

FIG. 16-37 MICHELOZZO DI BARTOLOMMEO, east facade of the Palazzo Medici-Riccardi (looking southwest) Florence, Italy, begun 1445.

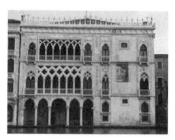

FIG. 16-37A Ca d'Oro, Venice, 1421–1437.

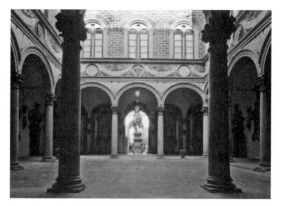

FIG. 16-38 MICHELOZZO DI BARTOLOMMEO, interior court of the Palazzo Medici-Riccardi (looking northwest), Florence, Italy, begun 1445.

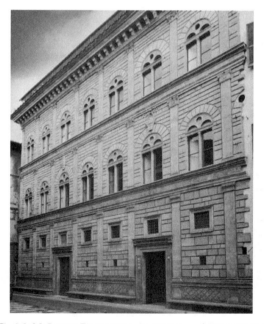

FIG. 16-39 LEON BATTISTA ALBERTI and BERNARDO ROSSELLINO, Palazzo Rucellai (looking northwest), Florence, Italy, ca. 1452–1470.

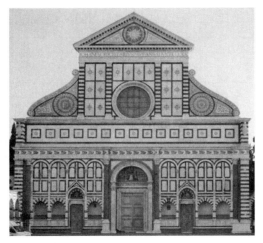

FIG. 16-40 LEON BATTISTA ALBERTI, west facade of Santa Maria Novella, Florence, Italy, 1456–1470.

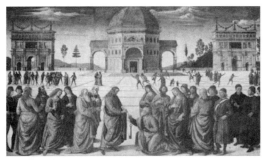

FIG. 16-41 PERUGINO, *Christ Delivering the Keys of the Kingdom to Saint Peter*, Sistine Chapel, Vatican, Rome, Italy, 1481–1483. Fresco, 11′ 5 1/2″ × 18′ 8 1/2″.

FIG. 16-41A MELOZZO DA FORLÌ, *Sixtus IV Confirming Platina*, ca. 1477–1481.

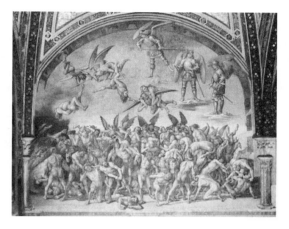

FIG. 16-42 Luca Signorelli, *The Damned Cast into Hell*, San Brizio chapel, Orvieto Cathedral, Orvieto, Italy, 1499–1504. Fresco, 23′ wide.

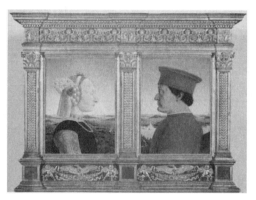

FIG. 16-43 Piero Della Francesca, *Battista Sforza and Federico da Montefeltro*, ca. 1472–1474. Oil and tempera on wood in modern frame, each panel 1′ 6 1/2″ × 1′ 1″. Galleria degli Uffizi, Florence.

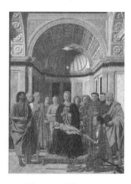

FIG. 16-43A Piero Della Francesca, *Brera Altarpiece*, ca. 1472–1474.

43

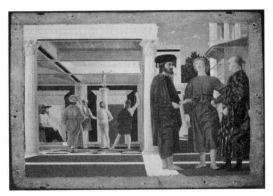

FIG. 16-44 PIERO DELLA FRANCESCA, *Flagellation*, ca. 1455–1465. Oil and tempera on wood, 1′11 1/8″ × 2′ 8 1/4″. Galleria Nazionale delle Marche, Urbino.

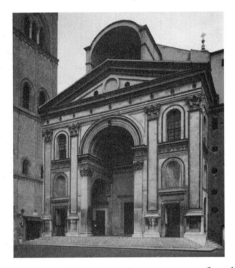

FIG. 16-45 LEON BATTISTA ALBERTI, west facade of Sant'Andrea, Mantua, Italy, designed 1470, begun 1472.

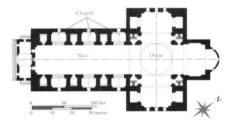

FIG. 16-46 LEON BATTISTA ALBERTI, plan of Sant'Andrea, Mantua, Italy, designed 1470, begun 1472.

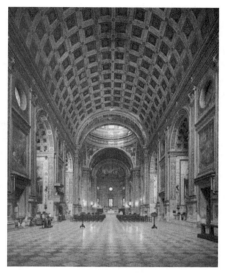

FIG. 16-47 Leon Battista Alberti, interior of Sant'Andrea (looking northeast), Mantua, Italy, designed 1470, begun 1472.

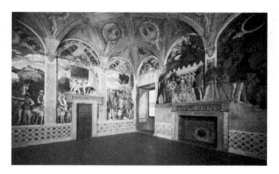

FIG. 16-48 Andrea Mantegna, interior of the Camera Picta (Painted Chamber), Palazzo Ducale, Mantua, Italy, 1465–1474. Fresco.

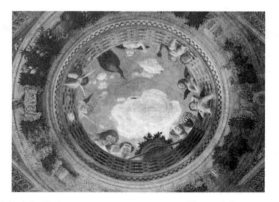

FIG. 16-49 Andrea Mantegna, ceiling of the Camera Picta (Painted Chamber), Palazo Ducale, Mantua, Italy, 1465–1474. Fresco, 8′ 9″ in diameter.

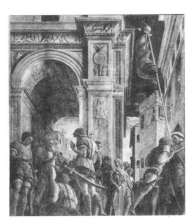

FIG. 16-49A MANTEGNA, *Saint James Led to Martyrdom*, 1454–1457.

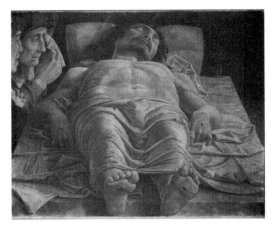

FIG. 16-50 ANDREA MANTEGNA, *Foreshortened Christ* (*Lamentation over the Dead Christ*), ca. 1500. Tempera on canvas, 2′ 2 3/4″ × 2′ 7 7/8″. Pinacoteca di Brera, Milan.

Chapter 17

Renaissance and Mannerism in Cinquecento Italy

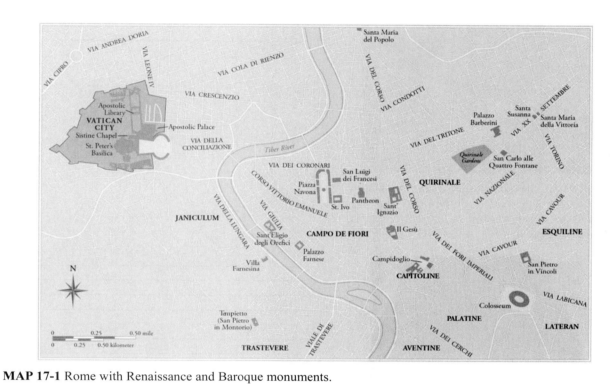

MAP 17-1 Rome with Renaissance and Baroque monuments.

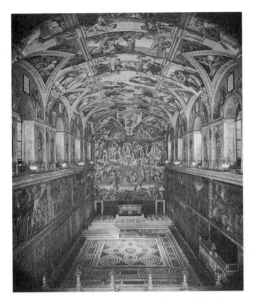

FIG. 17-01 Interior of the Sistine Chapel (looking west), Vatican City, Rome, Italy, built 1473; ceiling and altar wall frescoes by MICHELANGELO BUONARROTI, 1508–1512 and 1536–1541, respectively.

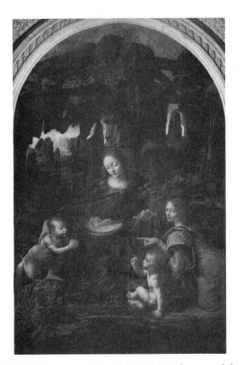

FIG. 17-02 LEONARDO DA VINCI, *Madonna of the Rocks*, from San Francesco Grande, Milan, Italy, begun 1483. Oil on wood (transferred to canvas), 6′ 6 1/2″ × 4′. Musée du Louvre, Paris.

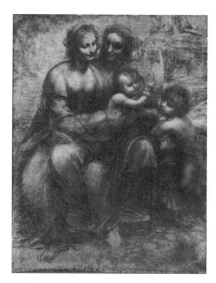

FIG. 17-03 LEONARDO DA VINCI, cartoon for *Madonna and Child with Saint Anne and the Infant Saint John*, ca. 1505–1507. Charcoal heightened with white on brown paper, 4′ 6″ × 3′ 3″. National Gallery, London.

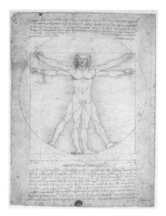

FIG. 17-03A LEONARDO, *Vitruvian Man*, ca. 1485–1490.

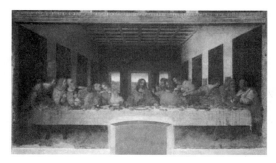

FIG. 17-04 LEONARDO DA VINCI, *Last Supper*, ca. 1495–1498. Oil and tempera on plaster, 13′ 9″ × 29′ 10″. Refectory, Santa Maria delle Grazie, Milan.

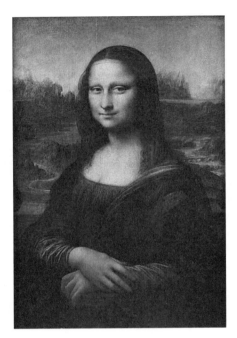

FIG. 17-05 LEONARDO DA VINCI, *Mona Lisa*, ca. 1503–1505. Oil on wood, 2′ 6 1/4″ × 1′ 9″. Musée du Louvre, Paris.

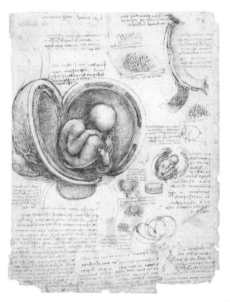

FIG. 17-06 LEONARDO DA VINCI, *The Fetus and Lining of the Uterus*, ca. 1511–1513. Pen and ink with wash over red chalk and traces of black chalk on paper, 1′ × 8 5/8″. Royal Library, Windsor Castle.

FIG. 17-06A LEONARDO, central-plan church, ca. 1487–1490.

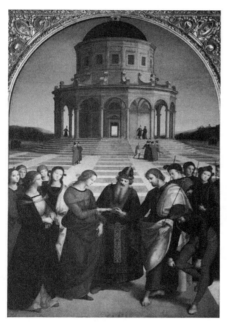

FIG. 17-07 RAPHAEL, *Marriage of the Virgin*, from the Chapel of Saint Joseph, San Francesco, Città di Castello, Italy, 1504. Oil on wood 5′ 7″ × 3′ 10 1/2″. Pinacoteca di Brera, Milan.

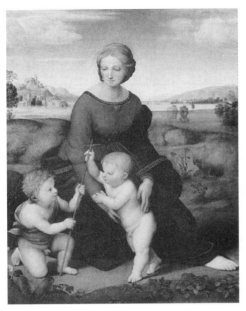

FIG. 17-08 RAPHAEL, *Madonna in the Meadow*, 1505–1506. Oil on wood, 3′ 8 1/2″ × 2′ 10 1/4″. Kunsthistorisches Museum, Vienna.

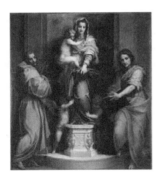

FIG. 17-08A ANDREA DEL SARTO, *Madonna of the Harpies*, 1517.

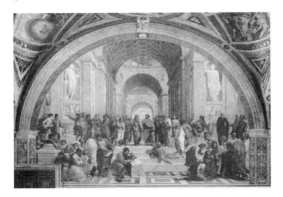

FIG. 17-09 RAPHAEL, *Philosophy* (*School of Athens*), Stanza della Segnatura, Vatican Palace, Rome, Italy, 1509–1511. Fresco, 19′ × 27′.

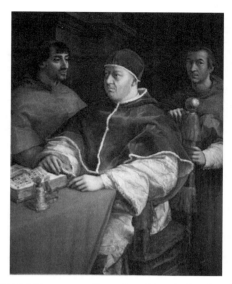

FIG. 17-10 RAPHAEL, *Pope Leo X with Cardinals Giulio de' Medici and Luigi de' Rossi*, ca. 1517. Oil on wood 5′ 5/8″ × 3′ 10 7′8″. Galleria degli Uffizi, Florence.

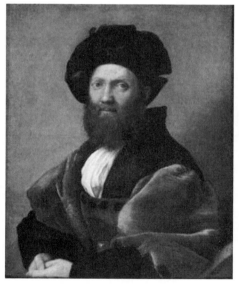

FIG. 17-10A RAPHAEL, *Baldassare Castiglione*, ca. 1514.

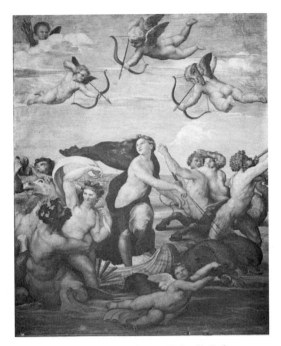

FIG. 17-11 RAPHAEL, *Galatea*, Sala di Galatea, Villa Farnesina, Rome, Italy, ca. 1513. Fresco, 9′ 8″ × 7′ 5″.

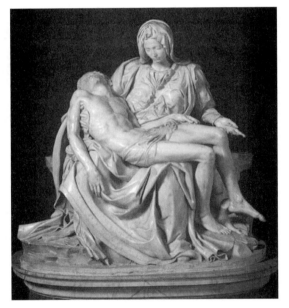

FIG. 17-12 MICHELANGELO BUONARROTI, *Pietà*, ca. 1498–1500. Marble, 5′ 8 1/2″ high. Saint Peter's, Vatican City, Rome.

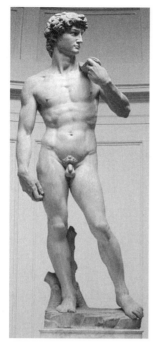

FIG. 17-13 MICHELANGELO BUONARROTI, *David*, from Piazza della Signoria, Florence, Italy, 1501–1504. Marble, 17′ high. Galleria dell'Accademia, Florence.

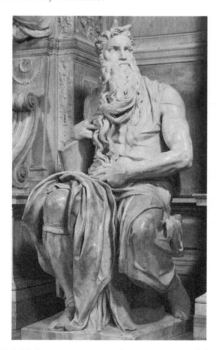

FIG. 17-14 MICHELANGELO BUONARROTI, *Moses*, from the tomb of Pope Julius II, Rome, Italy, ca. 1513–1515. Marble, 7′ 8 1/2″ high. San Pietro in Vincoli, Rome.

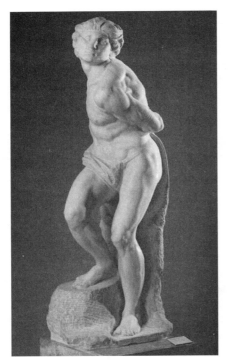

FIG. 17-15 MICHELANGELO BUONARROTI, *Bound Slave* (*Rebellious Slave*), from the tomb of Pope Julius II, Rome, Italy, ca. 1513–1516. Marble, 7′ 5/8″ high. Musée du Louvre, Paris.

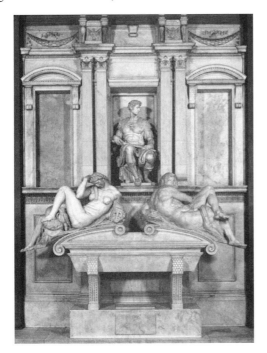

FIG. 17-16 MICHELANGELO BUONARROTI, tomb of Giuliano de' Medici, New Sacristy (Medici Chapel), San Lorenzo, Florence, Italy, 1519–1534. Marble, central figure 5′ 11″ high.

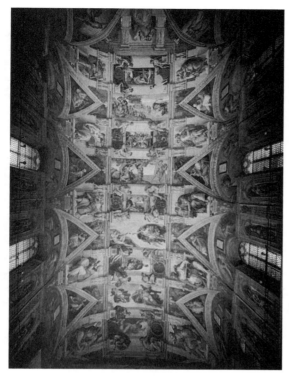

FIG. 17-17 MICHELANGELO BUONARROTI, ceiling of the Sistine Chapel, Vatican City, Rome, Italy, 1508–1512. Fresco, 128′ × 45′.

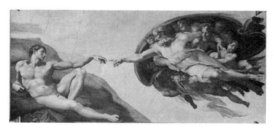

FIG. 17-18 MICHELANGELO BUONARROTI, *Creation of Adam*, detail of the ceiling of the Sistine Chapel (FIG 17-17), Vatican City, Rome, Italy, 1511–1512. Fresco, 9′ 2″ × 18′ 8″.

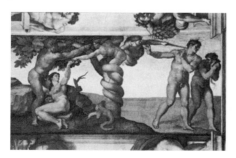

FIG. 17-18A MICHELANGELO, *Fall of Man*, ca. 1510.

FIG. 17-18B Sistine Chapel restoration, 1977–1989.

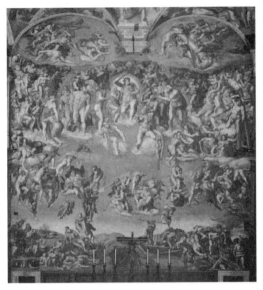

FIG. 17-19 MICHELANGELO BUONARROTI, *Last Judgment*, altar wall of the Sistine Chapel, Vatican City, Rome, Italy, 1536–1541. Fresco, 48′ × 44′.

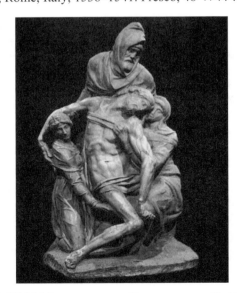

FIG. 17-20 MICHELANGELO BUONARROTI, *Pietà*, ca. 1547–1555. Marble, 7′ 8″ high. Museo dell' Opera del Duomo, Florence.

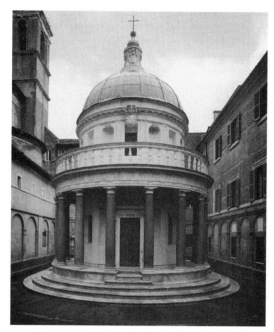

FIG. 17-21 DONATO D'ANGELO BRAMANTE, Tempietto, San Pietro in Montorio, Rome, Italy, begun 1502.

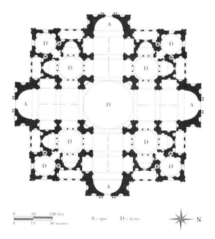

FIG. 17-22 DONATO D'ANGELO BRAMANTE, plan for Saint Peter's, Vatican City, Rome, Italy, 1505.

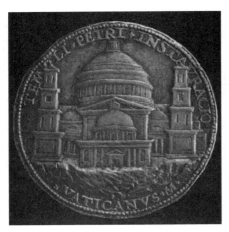

FIG. 17-23 CRISTOFORO FOPPA CARADOSSO, reverse side of a medal showing Bramante's design for Saint Peter's, 1506. Bronze, 2 1/4″ diameter. British Museum, London.

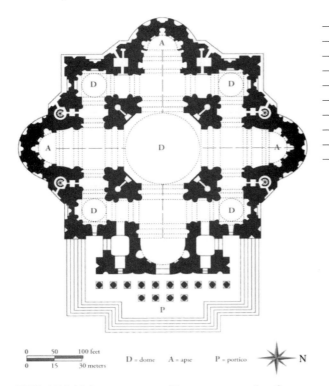

FIG. 17-24 MICHELANGELO BUONARROTI, plan for Saint Peter's, Vatican City, Rome, Italy, 1546.

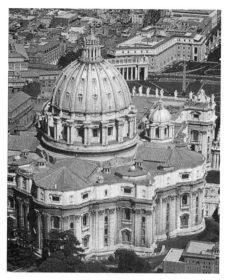

FIG. 17-25 MICHELANGELO BUONARROTI, Saint Peter's (looking northeast), Vatican City, Rome, Italy, 1546–1564. Dome completed by GIACOMO DELLA PORTA, 1590.

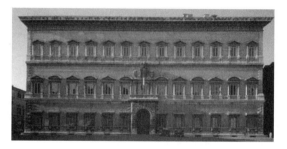

FIG. 17-26 ANTONIO DA SANGALLO THE YOUNGER, Palazzo Farnese (looking southeast), Rome, Italy, 1517–1546; completed by MICHELANGELO BUONARROTI, 1546–1550.

FIG. 17-26A MICHELANGELO, Campidoglio, Rome, 1538–1564.

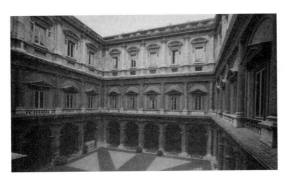

FIG. 17-27 ANTONIO DA SANGALLO THE YOUNGER, courtyard of the Palazzo Farnese, Rome, Italy, ca. 1517–1546. Third story and attic by MICHELANGELO BUONARROTI, 1546–1550.

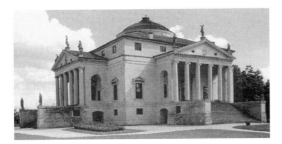

FIG. 17-28 ANDREA PALLADIO, Villa Rotonda (formerly Villa Capra; looking southwest), near Vicenza, Italy, ca. 1550–1570.

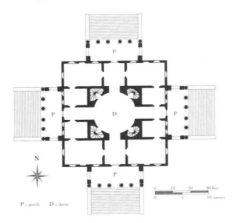

FIG. 17-29 ANDREA PALLADIO, plan of the Villa Rotonda (formerly Villa Capra), near Vicenza, Italy, ca. 1550–1570.

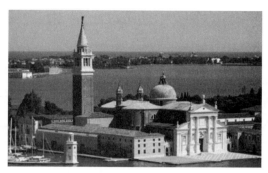

FIG. 17-30 ANDREA PALLADIO, San Giorgio Maggiore (looking southeast), Venice, Italy, begun 1566.

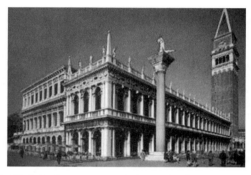

FIG. 17-30A SANSOVINO, Mint and Library, Venice, begun 1536.

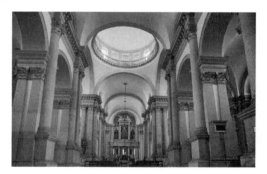

FIG. 17-31 ANDREA PALLADIO, interior of San Giorgio Maggiore (looking east), Venice, Italy, begun 1566.

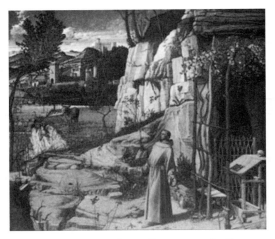

FIG. 17-31A BELLINI, *Saint Francis in the Desert*, ca. 1470–1480.

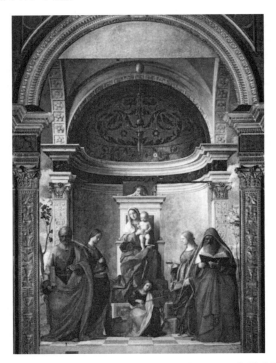

FIG. 17-32 GIOVANNI BELLINI, *Madonna and Child with Saints* (*San Zaccaria Altarpiece*), 1505. Oil on wood transferred to canvas, 16′ 5 1/2″ × 7′ 9″. San Zaccaria, Venice.

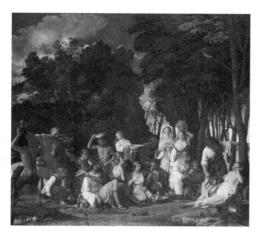

FIG. 17-33 GIOVANNI BELLINI and TITIAN, *Feast of the Gods*, from the Camerino d'Alabastro, Palazzo Ducale, Ferrara, Italy, 1529. Oil on canvas, 5′ 7″ × 6′ 2″. National Gallery of Art, Washington (Widener Collection).

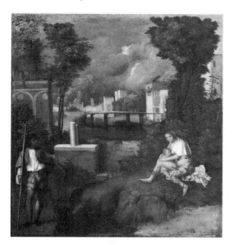

FIG. 17-34 GIORGIONE DA CASTELFRANCO, *The Tempest*, ca. 1510. Oil on canvas, 2′ 8 1/4″ × 2′ 4 3/4″. Galleria dell'Accademia, Venice.

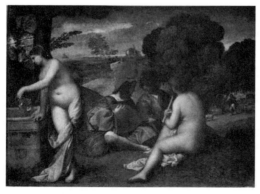

FIG. 17-35 TITIAN, *Pastoral Symphony*, ca. 1508–1511. Oil on canvas, 3′ 7 1/4″ × 4′ 6 1/4″. Musée du Louvre, Paris.

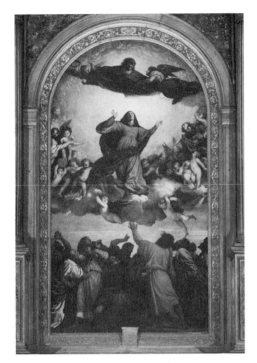

FIG. 17-36 TITIAN, *Assumption of the Virgin*,
1516–1518. Oil on wood, 22′ 7 1/2″ × 11′ 10″.
Santa Maria Gloriosa dei Frari, Venice.

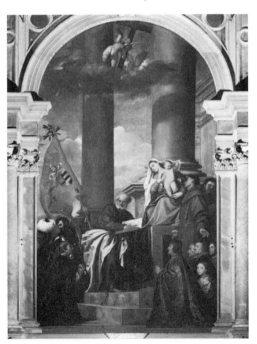

FIG. 17-37 TITIAN, *Madonna of the Pesaro
Family*, 1519–1526. Oil on canvas, 15′ 11″ × 8′ 10″.
Pesaro Chapel, Santa Maria Gloriosa dei Frari,
Venice.

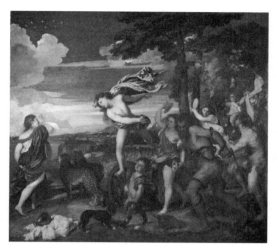

FIG. 17-38 Titian, *Meeting of Bacchus and Ariadne*, from the Camerino d'Alabastro, Palazzo Ducale, Ferrara, Italy, 1522–1523. Oil on canvas, 5′ 9″ × 6′ 3″. National Gallery, London.

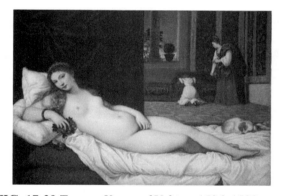

FIG. 17-39 Titian, *Venus of Urbino*, 1536–1538. Oil on canvas, 3′ 11″ × 5′ 5″. Galleria degli Uffizi, Florence.

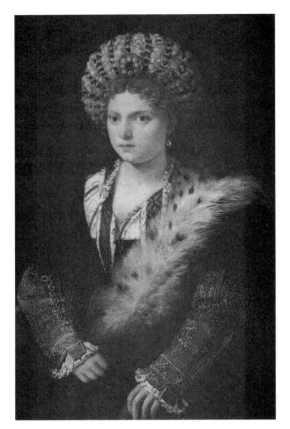

FIG. 17-40 TITIAN, *Isbella d'Este*, 1534–1536.
Oil on canvas, 3′ 4 1/8″ × 2′ 1 3/16″.
Kunsthistorisches Museum, Vienna.

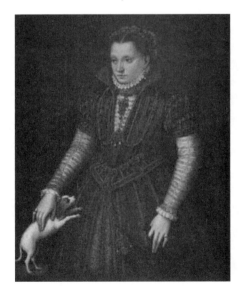

FIG. 17-40A FONTANA, *Portrait of a Noblewoman*,
ca 1580.

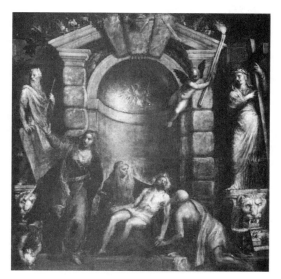

FIG. 17-41 TITIAN and PALMA IL GIOVANE, *Pietà*, ca. 1570–1576. Oil on canvas, 11′ 6″ × 12′ 9″. Galleria dell'Accademia, Venice.

FIG. 17-42 JACOPO DA PONTORMO, *Entombment of Christ*, Capponi chapel, Santa Felicità, Florence, Italy, 1525–1528. Oil on wood, 10′ 3″ × 6′ 4″.

FIG. 17-42A BECCAFUMI, *Fall of the Rebel Angels*, ca. 1524.

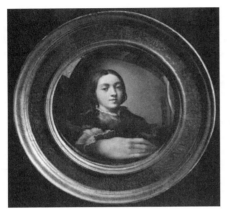

FIG. 17-43 PARMIGIANINO, *Self-Portrait in a Convex Mirror*, 1524. Oil on wood, 9 5/8″ diameter. Kunsthistorisches Museum, Vienna.

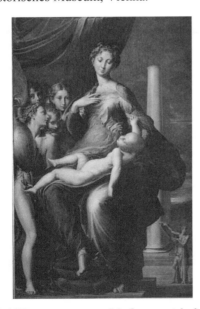

FIG. 17-44 PARAMIGININO, *Madonna with the Long Neck*, from the Baiardi Chapel, Santa Maria dei Servi, Parma, Italy, 1534–1540. Oil on wood, 7′ 1″ × 4′ 4″. Galleria degli Uffizi, Florence.

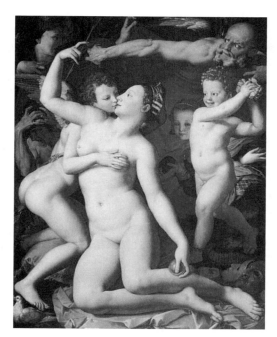

FIG. 17-45 BRONZINO, *Venus, Cupid, Folly, and Time*, ca. 1546. Oil on wood, 4′ 9 1/2″ × 3′ 9 3/4″. National Gallery, London.

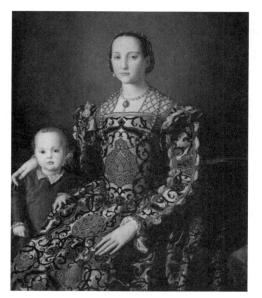

FIG. 17-46 BRONZINO, *Eleanora of Toledo and Giovanni de' Medici*, ca. 1546. Oil on wood, 3′ 9 1/4″ × 3′ 1 3/4″. Galleria degli Uffizi, Florence.

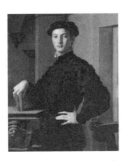

FIG. 17-46A BRONZINO, *Portrait of a Young Man*, ca. 1530–1545.

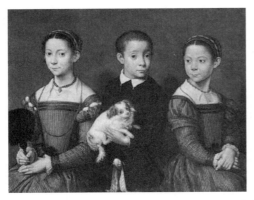

FIG. 17-47 SOFONISBA ANGUISSOLA, *Portrait of the Artist's Sisters and Brother*, ca. 1555. Oil on wood, 2′ 5 1/4″ × 3′ 1 1/2″. Methuen Collection, Corsham Court, Wiltshire.

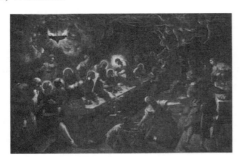

FIG. 17-48 TINTORETTO, *Last Supper*, 1594. Oil on canvas, 12′ × 18′ 8″. San Giorgio Maggiore, Venice.

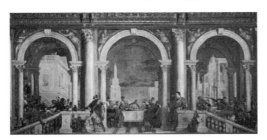

FIG. 17-49 PAOLO VERONESE, *Christ in the House of Levi*, from the refectory of Santi Giovanni e Paolo, Venice, Italy, 1573. Oil on canvas, 18′ 3″ × 42′. Galleria dell'Accademia, Venice.

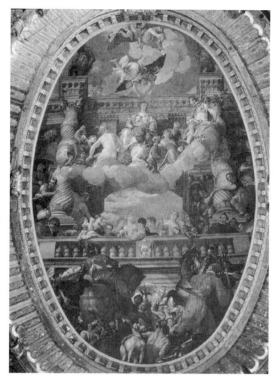

FIG. 17-50 PAOLO VERONESE, *Triumph of Venice*, ca. 1585. Oil on canvas, 29′ 8″ × 19′. Hall of the Grand Council, Doge's Palace, Venice.

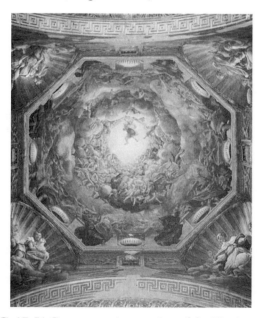

FIG. 17-51 CORREGIO, *Assumption of the Virgin*, 1526–1530. Fresco, 35′ 10″ × 37′ 11″. Parma Cathedral, Parma.

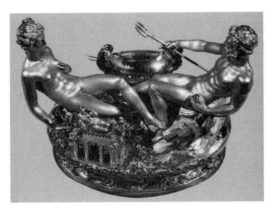

FIG. 17-52 BENVENUTO CELLINI, *Saltcellar of Francis I*, 1540–1543. Gold, enamel, and ebony, 10 1/4″ × 1′ 1 1/8″. Kunsthistorisches Museum, Vienna.

FIG. 17-52A CELLINI, *Genius of Fontainebleau*, 1542–1543.

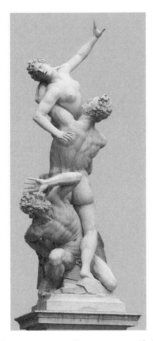

FIG. 17-53 GIOVANNI DA BOLOGNA, *Abduction of the Sabine Women*, Loggia dei Lanzi, Piazza della Signoria, Florence, Italy, 1579–1583. Marble, 13′ 5 1/2″ high.

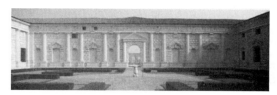

FIG. 17-54 Giulio Romano, courtyard of the Palazzo del Tè (looking southeast), Mantua, Italy, 1525–1535.

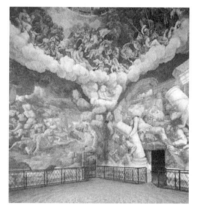

FIG. 17-54A Giulio Romano, *Fall of the Giants*, 1530–1532.

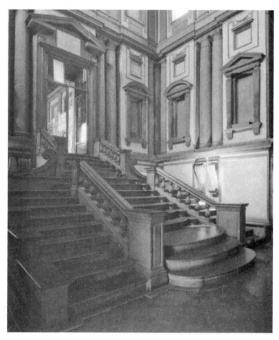

FIG. 17-55 Michelangelo Buonarroti, vestibule of the Laurentian Library, Florence, Italy, 1524–1534; staircase, 1558–1559.

75

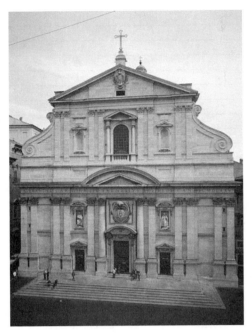

FIG. 17-56 GIACOMO DELLA PORTA, west facade of Il Gesù, Rome, Italy, ca. 1575–1584.

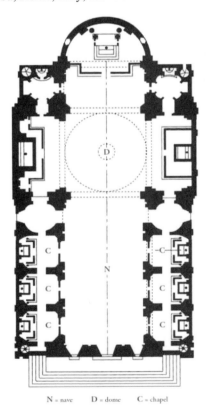

N = nave D = dome C = chapel

FIG. 17-57 GIACOMO DA VIGNOLA, plan of Il Gesù, Rome, Italy, 1568.

Chapter 18

High Renaissance and Mannerism in Northern Europe and Spain

MAP 18-1 Europe in the early 16th century.

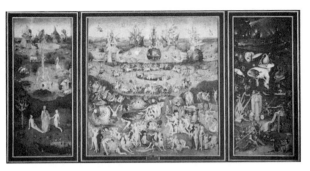

FIG. 18-01 HIERONYMUS BOSCH, *Garden of Earthly Delights*, 1505–1510. Oil on wood, center panel 7′ 2 5/8″ × 6′ 4 3/4″, each wing 7′2 5/8″× 3′2 1/4″. Museo del Prado, Madrid.

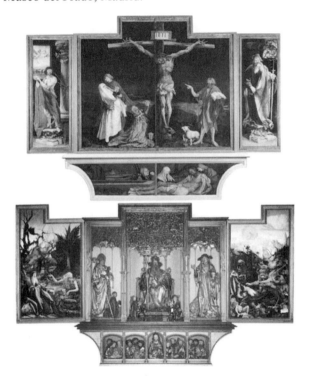

FIG. 18-02 MATTHIAS GRÜNEWALD, *Isenheim Altarpiece* (closed *top;* open, *bottom*), from the chapel of the Hospital of Saint Anthony, Isenheim, Germany, ca. 1510–1515. Oil on wood, center panel 9′ 9 1/2″ × 10′ 9″, each wing 8′ 2 1/2″ × 3′ 1/2″, predella 2′ 5 1/2″ × 11′ 2″. Shrine carved by NIKOLAUS HAGENAUER, ca. 1505. Painted and gilt limewood, 9′ 9 1/2″ × 10′ 9″. Musée d'Unterlinden, Colmar.

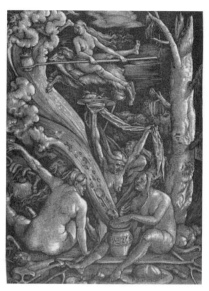

FIG. 18-03 HANS BALDUNG GRIEN, *Witches' Sabbath*, 1510. Chiaroscuro woodcut, 1′ 2 7/8″ × 10 1/4″. British Museum, London.

FIG. 18-03A BALDUNG GRIEN, *Death and the Maiden*, 1509–1511.

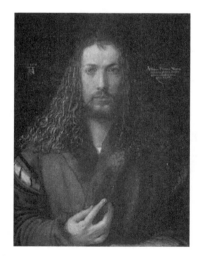

FIG. 18-04 ALBRECHT DÜRER, *Self-Portrait*, 1500. Oil on wood, 2′ 2 1/4″ × 1′ 7 1/4″. Alte Pinakothek, Munich.

FIG. 18-04A DÜRER, *Great Piece of Turf*, 1503.

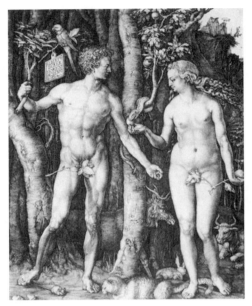

FIG. 18-05 ALBRECHT DÜRER, *Fall of Man*
(*Adam and Eve*), 1504. Engraving, 9 7/8″ × 7 5/8″.
Museum of Fine Arts, Boston (centennial gift of
Landon T. Clay).

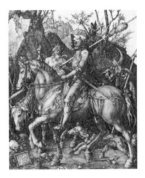

FIG. 18-05A DÜRER, *Knight, Death, and the
Devil*, 1513.

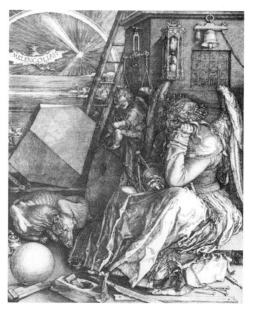

FIG. 18-06 ALBRECHT DÜRER, *Melencolia I*, 1514. Engraving, 9 3/8″ × 7 1/2″. Victoria & Albert Museum, London.

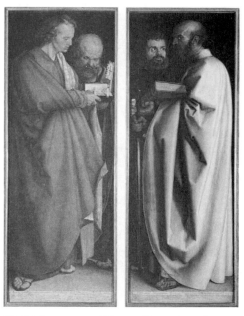

FIG. 18-07 ALBRECHT DÜRER, *Four Apostles*, 1526. Oil on wood, each panel 7′ 1″ × 2′ 6″. Alte Pinakothek, Munich.

FIG. 18-08 LUCAS CRANACH THE ELDER, *Law and Gospel*, ca. 1530. Woodcut, 10 5/8″ × 1′ 3/4″. British Museum, London.

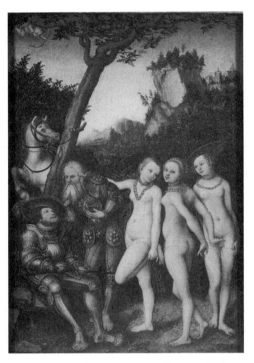

FIG. 18-09 LUCAS CRANACH THE ELDER, *Judgment of Paris*, 1530. Oil on wood 1′ 1 1/2″ × 9 1/2″. Staatliche Kunsthalle, Karlsruhe.

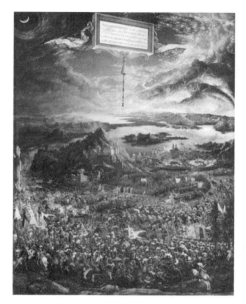

FIG. 18-10 ALBRECHT ALTDORFER, *Battle of Issus*, 1529. Oil on wood, 5′ 2 1/4″ × 3′ 11 1/4″. Alte Pinakothek, Munich.

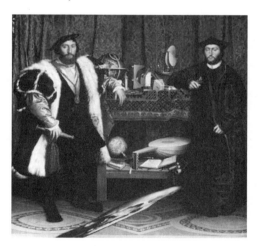

FIG. 18-11 HANS HOLBEIN THE YOUNGER, *The French Ambassadors*, 1533. Oil and tempera on wood, 6′ 8″ × 6′ 9 1/2″. National Gallery, London.

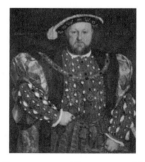

FIG. 18-11A HOLBEN THE YOUNGER, *Henry VIII*, 1540.

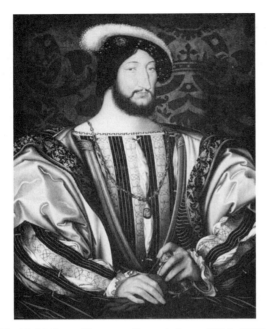

FIG. 18-12 Jean Clouet, *Francis I*, ca. 1525–1530. Tempera and oil on wood, 3′ 2″ × 2′ 5″. Musée du Louvre, Paris.

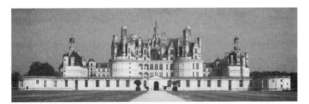

FIG. 18-13 Château de Chambord (looking northwest), Chambord, France, begun 1519.

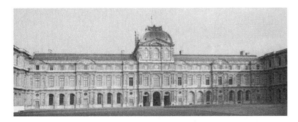

FIG. 18-14 Pierre Lescot, west wing of the Cour Carré (Square Court, looking west) of the Louvre, Paris, France, begun 1546.

FIG. 18-14A GOUJON, Fountain of the Innocents, 1547–1549.

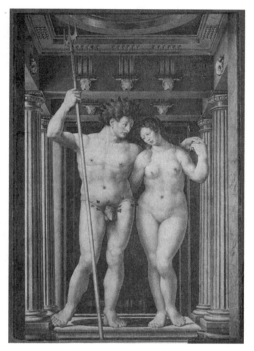

FIG. 18-15 JAN GOSSAERT, *Neptune and Amphitrite*, ca. 1516. Oil on wood, 6′ 2″ × 4′ 3/4″. Gemäldegalerie, Staatliche Museen zu Berlin, Berlin.

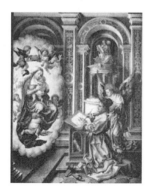

FIG. 18-15A GOSSAERT, *Saint Luke Drawing the Virgin*, ca. 1520–1525.

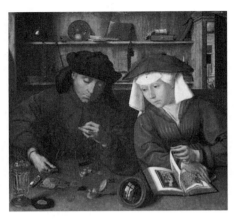

FIG. 18-16 QUINTEN MASSYS, *Money-Changer and His Wife*, 1514. Oil on wood, 2′ 3 3/4″ × 2′ 2 3/8″. Musée du Louvre, Paris.

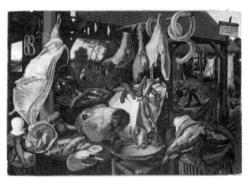

FIG. 18-17 PIETER AERTSEN, *Butcher's Stall*, 1551. Oil on wood, 4′ 3/8″ × 6′ 5 3/4″. Uppsala University Art Collection, Uppsala.

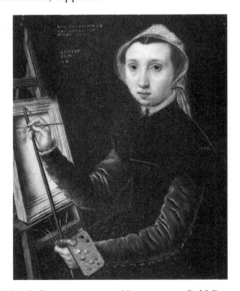

FIG. 18-18 CATERINA VAN HEMESSEN, *Self-Portrait*, 1548. Oil on wood, 1′ 3/4″ × 9 7/8″. Kunstmuseum, Basel, Basel.

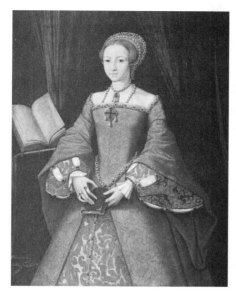

FIG. 18-19 Attributed to LEVINA TEERLINC, *Elizabeth I as a Princess*, ca. 1559. Oil on wood 3′ 6 3/4″ × 2′ 8 1/4″. Royal Collection, Windsor Castle, Windsor.

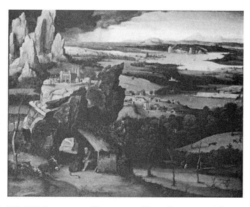

FIG. 18-20 JOACHIM PATINIR, *Landscape with Saint Jerome*, ca. 1520–1524. Oil on wood, 2′ 5 1/8″ × 2′ 11 7/8″. Museo del Prado, Madrid.

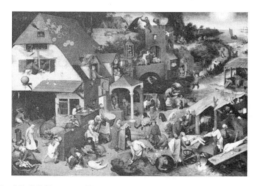

FIG. 18-21 PIETER BRUEGEL THE ELDER, *Netherlandish Proverbs*, 1559. Oil on wood, 3′ 10″ × 5′ 4 1/8″. Gemäldegalerie, Staatliche Museen zu Berlin, Berlin.

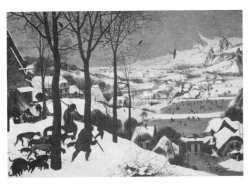

FIG. 18-22 PIETER BRUEGEL THE ELDER, *Hunters in the Snow*, 1565. Oil on wood, 3′ 10 1/8″ × 5′ 3 3/4″. Kunsthistorisches Museum, Vienna.

FIG. 18-22A BRUEGEL THE ELDER, *Fall of Icarus*, ca. 1555–1556.

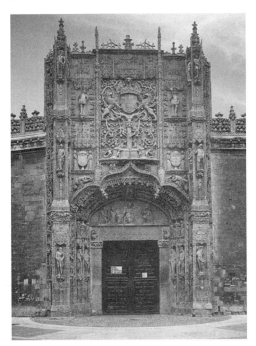

FIG. 18-23 Portal, Colegio de San Gregorio, Valladolid, Spain, ca. 1498.

FIG. 18-23A Casa de Montejo, Mérida, 1549.

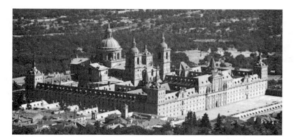

FIG. 18-24 Juan de Herrera and Juan Bautista de Toledo, aerial view (looking southeast) of El Escorial, near Madrid, Spain, 1563–1584.

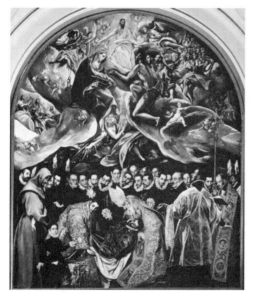

FIG. 18-25 El Greco, *Burial of Count Orgaz*, 1586. Oil on canvas, 16′ × 12′. Santo Tomé, Toledo.

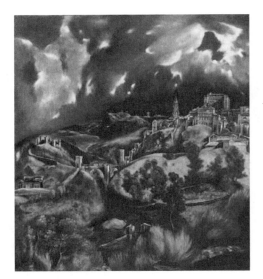

FIG. 18-26 EL GRECO, *View of Toledo*, ca. 1610.
Oil on canvas, 3′ 11 3/4″ × 3′ 6 3/4″. Metropolitan
Museum of Art, New York (H.O. Havemeyer
Collection. Bequest of Mrs. H.O. Havemeyer, 1929).

Chapter 19

The Baroque in Italy and Spain

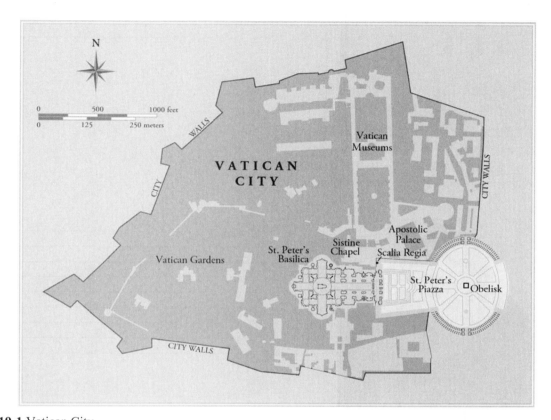

MAP 19-1 Vatican City.

FIG. 19-01 GIANLORENZO BERNINI, Fountain of the Four Rivers (looking southwest with Sant'Agnese in Agone in the background), Piazza Navona, Rome, Italy, 1648–1651.

FIG. 19-02 CARLO MADERNO, facade of Santa Susanna (looking north), Rome, Italy, 1597–1603.

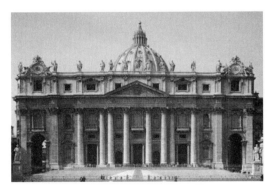

FIG. 19-03 CARLO MADERNO, east facade of Saint Peter's, Vatican City, Rome, Italy, 1606–1612.

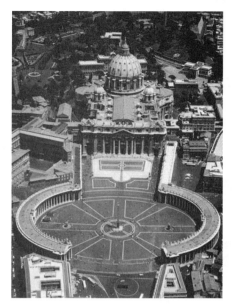

FIG. 19-04 Aerial view of Saint Peter's (looking west), Vatican City, Rome, Italy. Piazza designed by GIANLORENZO BERNINI, 1656–1667.

FIG. 19-04A BERNINI, Scala Regia, Vatican, 1663–1666.

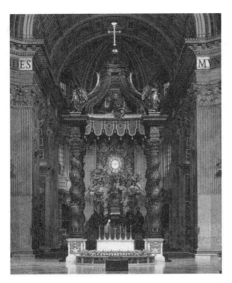

FIG. 19-05 GIANLORENZO BERNINI, baldacchino (looking west), Saint Peter's, Vatican City, Rome, Italy, 1624–1633.

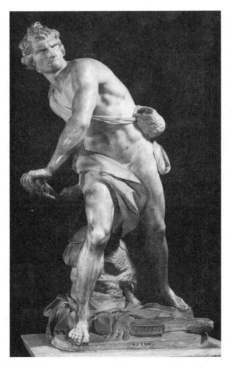

FIG. 19-06 GIANLORENZO BERNINI, *David*, 1623. Marble, 5′ 7″ high. Galleria Borghese, Rome.

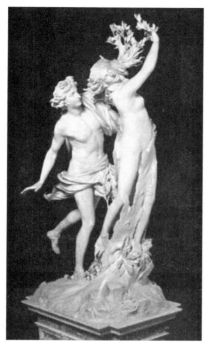

FIG. 19-06A BERNINI, *Apollo and Daphne*, 1623–1624.

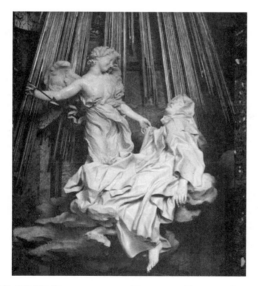

FIG. 19-07 GIANLORENZO BERNINI, *Estasy of Saint Teresa*, Cornaro chapel, Santa Maria della Vittoria, Rome, Italy, 1645–1652. Marble, height of group 11′ 6″.

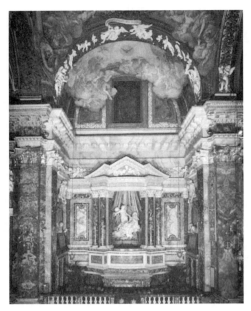

FIG. 19-08 GIANLORENZO BERNINI, Cornaro chapel, Santa Maria della Vittoria, Rome, Italy, 1645–1652.

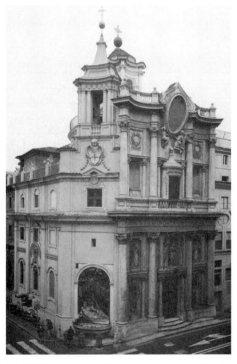

FIG. 19-09 FRANCESCO BORROMINI, facade of San Carlo alle Quattro Fontane (looking south), Rome, Italy, 1638–1641.

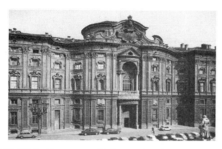

FIG. 19-09A GUARINI, Palazzo Carignano, Turin, 1679–1692.

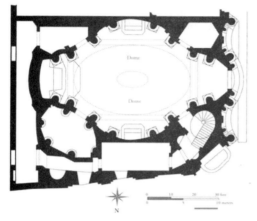

FIG. 19-10 FRANCESCO BORROMINI, plan of San Carlo alle Quattro Fontane, Rome, Italy, 1638–1641.

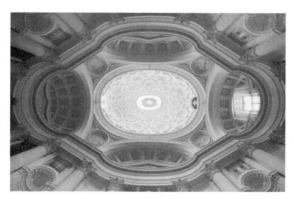

FIG. 19-11 FRANCESCO BORROMINI, San Carlo alle Quattro Fontane (view into dome), Rome, Italy, 1638–1641.

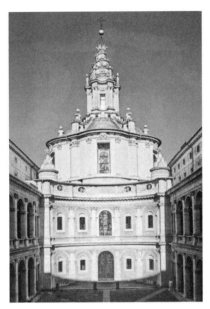

FIG. 19-12 FRANCESCO BORROMINI, Chapel of
Saint Ivo (looking east), College of the Sapienza,
Rome, Italy, begun 1642.

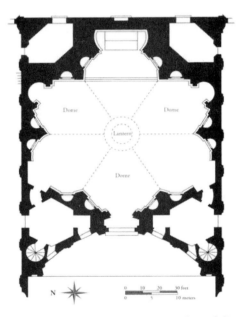

FIG. 19-13 FRANCESCO BORROMINI, plan of the
Chapel of Saint Ivo, College of the Sapienza, Rome,
Italy, begun 1642.

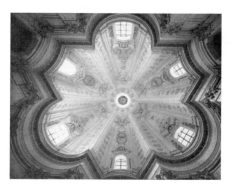

FIG. 19-14 FRANCESCO BORROMINI, Chapel of Saint Ivo (view into dome), College of the Sapienza, Rome, Italy, begun 1642.

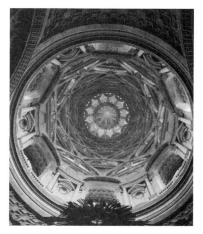

FIG. 19-14A GUARINI, Chapel of the Holy Shroud, Turin, 1667–1694.

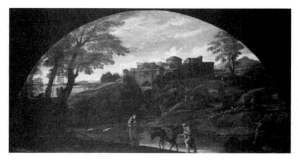

FIG. 19-15 ANNIBALE CARRACCI, _Flight into Egypt_, 1603–1604. Oil on canvas, 4′ × 7′ 6″. Galleria Doria Pamphili, Rome.

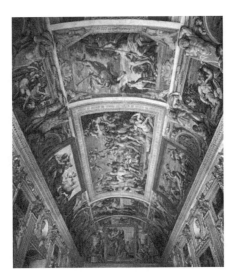

FIG. 19-16 ANNIBALE CARRACCI, *Loves of the Gods*, ceiling frescoes in the gallery, Palazzo Farnese (FIG. 17-26), Rome, Italy, 1597–1601.

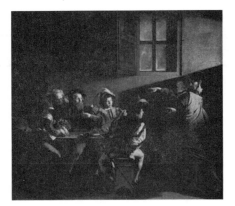

FIG. 19-17 CARAVAGGIO, *Calling of Saint Matthew*, ca. 1597–1601. Oil on canvas, 11′ 1″ × 11′ 5″. Contarelli chapel, San Luigi dei Francesi, Rome.

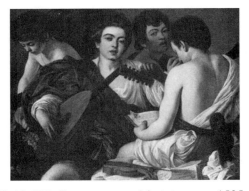

FIG. 19-17A CARAVAGGIO, *Musicians*, ca. 1595.

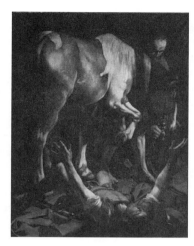

FIG. 19-18 CARAVAGGIO, *Conversion of Saint Paul*, ca. 1601. Oil on canvas, 7′ 6″ × 5′ 9″. Cerasi chapel, Santa Maria del Popolo, Rome.

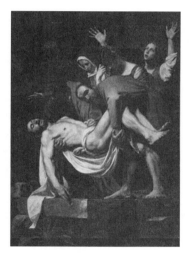

FIG. 19-18A CARAVAGGIO, *Entombment*, ca. 1603.

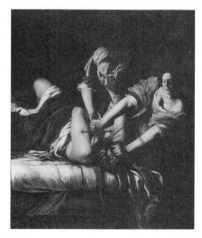

FIG. 19-19 ARTEMISIA GENTILESCHI, *Judith Slaying Holofernes*, ca. 1614–1620. Oil on canvas, 6′ 6 1/3″ × 5′ 4″. Galleria degli Uffizi, Florence.

101

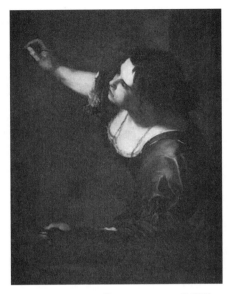

FIG. 19-20 ARTEMISIA GENTILESCHI, *Self-Portrait as the Allegory of Painting*, ca. 1638–1639. Oil on canvas, 3′ 2 7/8″ × 2′ 5 5/8″. Royal Collection, Kensington Palace, London.

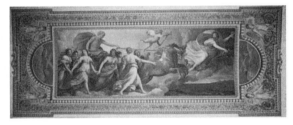

FIG. 19-21 GUIDO RENI, *Aurora*, ceiling fresco in the Casino Rospigliosi, Rome, Italy, 1613–1614.

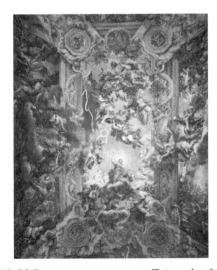

FIG. 19-22 PIETRO DA CORTONA, *Triumph of the Barberini*, ceiling fresco in the Gran Salone, Palazzo Barberini, Rome, Italy, 1633–1639.

102

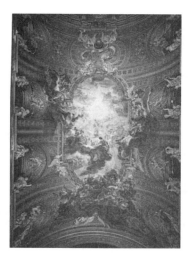

FIG. 19-23 GIOVANNI BATTISTA GAULLI, *Triumph of the Name of Jesus*, ceiling fresco with stucco figures on the nave vault of Il Gesù, (FIG. 17-56), Rome, Italy, 1676–1679.

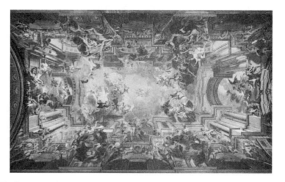

FIG. 19-24 FRA ANDREA POZZO, *Glorification of Saint Ignatius*, ceiling fresco in the nave of Sant'Ignazio, Rome, Italy, 1691–1694.

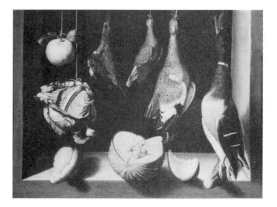

FIG. 19-25 JUAN SÁNCHEZ COTÁN, *Still Life with Game Fowl*, ca. 1600–1603. Oil on canvas, 2′ 2 3/4″ × 2′ 10 7/8″. Art Institute of Chicago, Chicago (gift of Mr. and Mrs. Leigh B. Block).

103

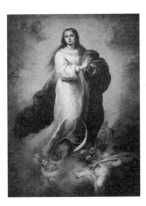

FIG. 19-25A MURILLO, *Immaculate Conception*, ca. 1661–1670.

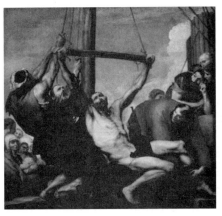

FIG. 19-26 JOSÉ DE RIBERA, *Martyrdom of Saint Philip*, ca. 1639. Oil on canvas, 7′ 8″ × 7′ 8″. Museao del Prado, Madrid.

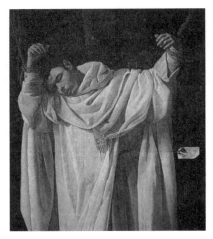

FIG. 19-27 FRANCISCO DE ZURBARÁN, *Saint Serapion*, 1628. Oil on canvas, 3′ 11 1/2″ × 3′ 4 3/4″. Wadsworth Atheneum Museum of Art, Hartford (The Ella Gallup Sumner and Mary Catlin Sumner Collection Fund).

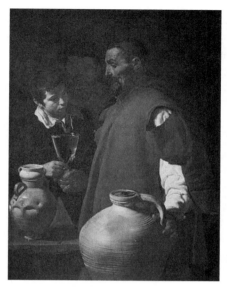

FIG. 19-28 DIEGO VELÁZQUEZ, *Water Carrier of Seville*, ca. 1619. Oil on canvas, 3′ 5 1/2″ × 2 7 1/2″. Victoria & Albert Museum, London.

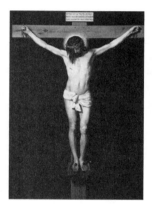

FIG. 19-28A VELÁZQUEZ, *Christ on the Cross*, ca. 1631–1632.

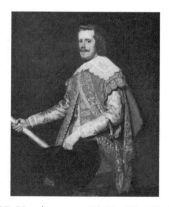

FIG. 19-28B VELÁZQUEZ, *Philip IV*, 1644.

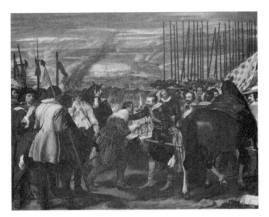

FIG. 19-29 DIEGO VELÁZQUEZ, *Surrender of Breda*, 1634–1635. Oil on canvas, 10′ 1″ × 12′ 1/2″. Museo del Prado, Madrid.

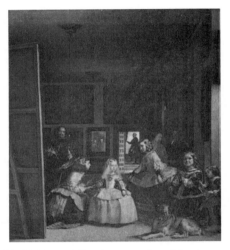

FIG. 19-30 DIEGO VELÁZQUEZ, *Las Meninas* (*The Maids of Honor*), 1656. Oil on canvas, 10′ 5″ × 9′. Museo del Prado, Madrid.

Chapter 20

The Baroque in Northern Europe

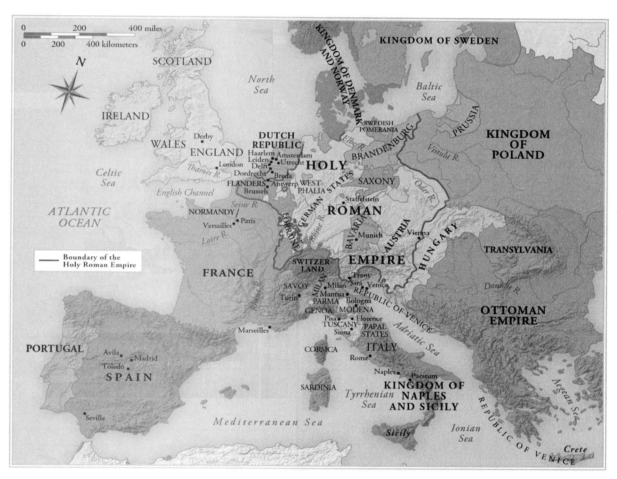

MAP 20-1 Europe in 1648 after the Treaty of Westphalia.

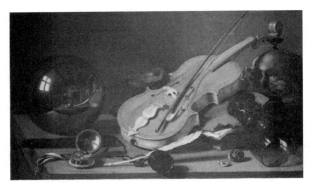

FIG. 20-01 PIETER CLAESZ, *Vanitas Still Life*, 1630s. Oil on panel, 1 ′2″ × 1′ 11 1/2″. Germanisches Nationalmuseum, Nuremberg.

FIG. 20-01A BRUEGEL and RUBENS, *Allegory of Sight*, ca. 1617–1618.

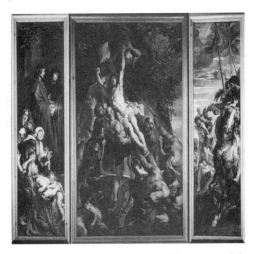

FIG. 20-02 PETER PAUL RUBENS, *Elevation of the Cross*, from Saint Walburga, Antwerp, 1610. Oil on wood, center panel 15′ 1 7/8″ × 11′ 1 1/2″, each wing 15′ 1 7/8″ × 4′ 11″. Antwerp Cathedral, Antwerp.

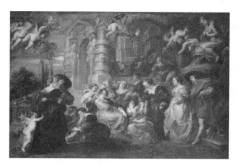

FIG. 20-02A RUBENS, *Garden of Love*, 1630–1632.

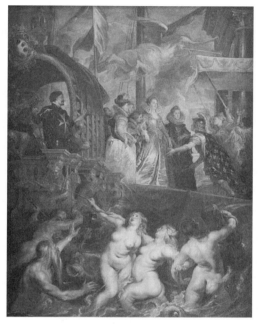

FIG. 20-03 PETER PAUL RUBENS, *Arrival of Marie de'
Medici at Marseilles*, 1622–1625. Oil on canvas,
12′ 11 1/2″ × 9′ 7″. Musée du Louvre, Paris.

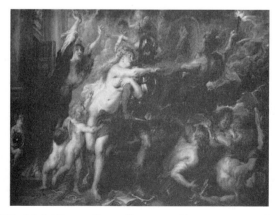

FIG. 20-04 PETER PAUL RUBENS, *Consequences of
War*, 1638–1639. Oil on canvas, 6′ 9″ × 11′ 3 7/8″.
Palazzo Pitti, Florence.

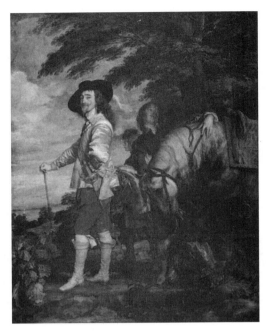

FIG. 20-05 ANTHONY VAN DYCK, *Charles I Dismounted*, ca. 1635. Oil on canvas, 8′ 11″ × 6′ 11 1/2″. Musée, du Louvre, Paris.

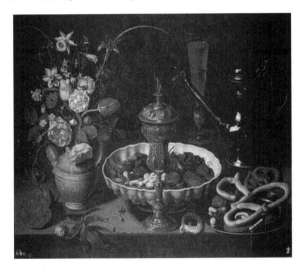

FIG. 20-06 CLARA PEETERS, *Still Life with Flowers, Goblet, Dried Fruit, and Pretzels*, 1611. Oil on panel, 1′ 7 3/4″ × 2′ 1 1/4″. Museo del Prado, Madrid.

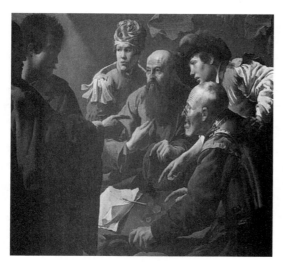

FIG. 20-07 HENDRICK TER BRUGGHEN, *Calling of Saint Matthew*, 1621. Oil on canvas, 3′ 4″ × 4′ 6″. Centraal Museum, Utrecht.

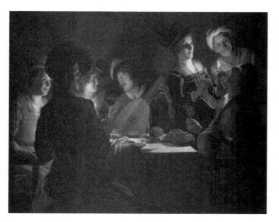

FIG. 20-08 GERRIT VAN HONTHORST, *Supper Party*, 1620. Oil on canvas, 4′ 8″ × 7′. Galleria degli Uffizi, Florence.

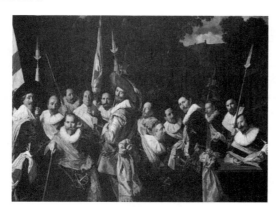

FIG. 20-09 FRANS HALS, *Archers of Saint Hadrian*, ca. 1633. Oil on canvas, 6′ 9″ × 11′. Frans Halsmuseum, Haarlem.

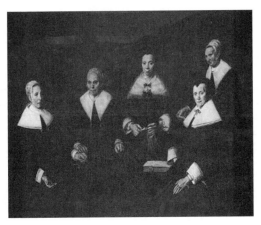

FIG. 20-10 FRANS HALS, *The Women Regents of the Old Men's Home at Haarlem*, 1664. Oil on canvas, 5′ 7″ × 8′ 2″. Frans Halsmuseum, Haarlem.

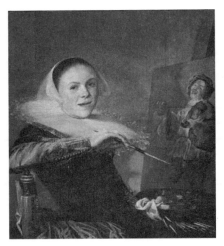

FIG. 20-11 JUDITH LEYSTER, *Self-Portrait*, ca. 1630. Oil on canvas, 2′ 5 3/8″ × 2′ 1 5/8″. National Gallery of Art, Washington, D.C. (gift of Mr. and Mrs. Robert Woods Bliss).

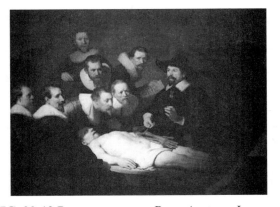

FIG. 20-12 REMBRANDT VAN RIJN, *Anatomy Lesson of Dr. Tulp*, 1632. Oil on canvas, 5′ 3 3/4″ × 7′ 1 1/4″. Mauritshuis, The Hague.

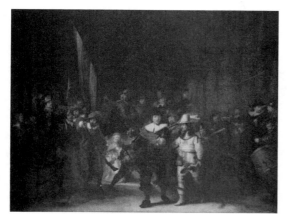

FIG. 20-13 REMBRANDT VAN RIJN, *The Company of Captain Frans Banning Cocq* (*Night Watch*), 1642. Oil on canvas, 11′ 11″ × 14′ 4″ (trimmed from original size). Rijksmuseum, Amsterdam.

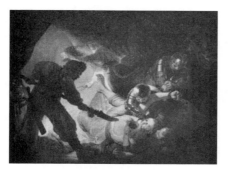

FIG. 20-13A REMBRANDT, *Blinding of Samson*, 1636.

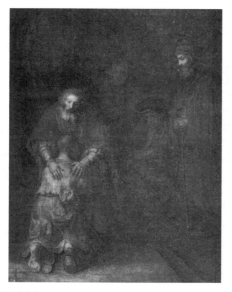

FIG. 20-14 REMBRANDT VAN RIJN, *Return of the Prodigal Son*, ca. 1665. Oil on canvas, 8′ 8″ × 6′ 9″. Hermitage Museum, Saint Petersburg.

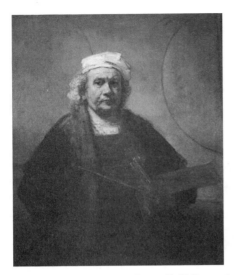

FIG. 20-15 REMBRANDT VAN RIJN, *Self-Portrait*, ca. 1659–1660. Oil on canvas, 3′ 8 3/4″ × 3′ 1″. Kenwood House, London (Iveagh Bequest).

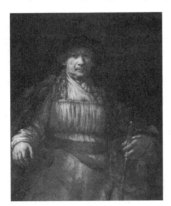

FIG. 20-15A REMBRANDT, *Self-Portrait*, 1658.

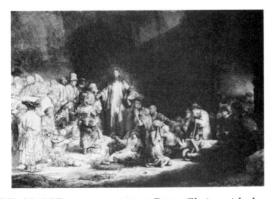

FIG. 20-16 REMBRANDT VAN RIJN, *Christ with the Sick around Him, Receiving the Children* (*Hundred-Guilder Print*), ca. 1649. Etching, 11″ × 1′ 3 1/4″. Pierpont Morgan Library, New York.

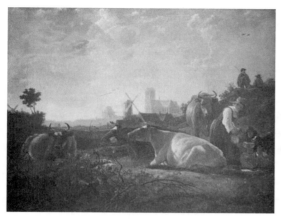

FIG. 20-17 AELBERT CUYP, *Distant View of Dordrecht, with a Milkmaid and Four Cows, and Other Figures* (*The "Large Dort"*), late 1640s. Oil on canvas, 5′ 1″ × 6′ 4 7/8″. National Gallery, London.

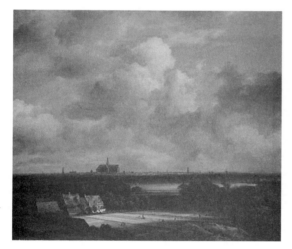

FIG. 20-18 JACOB VAN RUISDAEL, *View of Haarlem from the Dunes at Overveen*, ca. 1670. Oil on canvas, 1′ 10″ × 2′ 1″. Mauritshuis, The Hague.

FIG. 20-18A RUISDAEL, *Jewish Cemetery*, ca. 1655–1660.

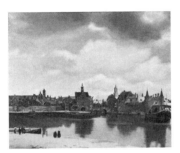

FIG. 20-18B VERMEER, *View of Delft*, ca. 1661.

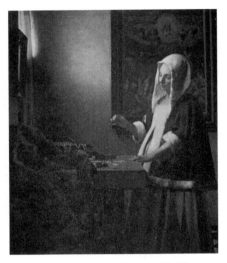

FIG. 20-19 JAN VERMEER, *Woman Holding a Balance*, ca. 1664. Oil on canvas, 1′ 3 5/8″ × 1′ 2″. National Gallery of Art, Washington, D.C. (Widener Collection).

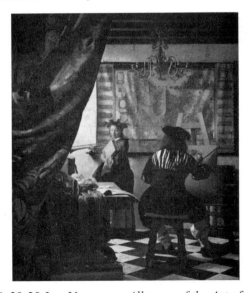

FIG. 20-20 JAN VERMEER, *Allegory of the Art of Painting*, 1670–1675. Oil on canvas, 4′ 4″ × 3′ 8″. Kunsthistorisches Museum, Vienna.

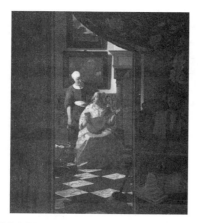

FIG. 20-20A VERMEER, *The Letter*, 1666.

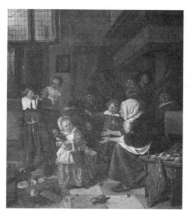

FIG. 20-21 JAN STEEN, *Feast of Saint Nicholas*,
ca. 1660–1665. Oil on canvas, 2′ 8 1/4″ × 2′ 3 3/4″.
Rijksmuseum, Amsterdam.

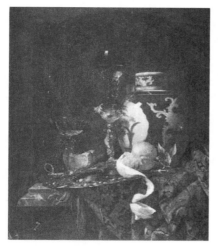

FIG. 20-22 WILLEM KALF, *Still Life with a Late Ming
Ginger Jar*, 1669. Oil on canvas, 2′ 6″ × 2′ 1 3/4″.
Indianapolis Museum of Art, Indianapolis (gift in
commemoration of the 60th anniversary of the Art
Association of Indianapolis, in memory of Daniel W.
and Elizabeth C. Marmon).

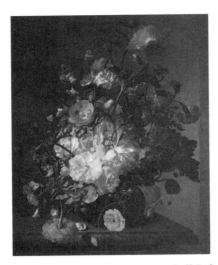

FIG. 20-23 RACHEL RUYSCH, *Flower Still Life*, after 1700. Oil on canvas, 2′ 5 3/4″ × 1′ 11 7/8″. Toledo Museum of Art, Toledo (purchased with funds from the Libbey Endowment, gift of Edward Drummond Libbey).

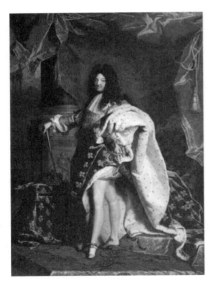

FIG. 20-24 HYACINTHE RIGAUD, *Louis XIV*, 1701. Oil on canvas, 9′ 2″ × 6′ 3″. Musée du Louvre, Paris.

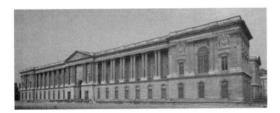

FIG. 20-25 CLAUDE PERRAULT, *Louis Le Vau*, and *Charles Le Brun*, east facade of the Louvre (looking southwest), Paris, France, 1667–1670.

118

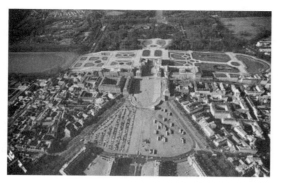

FIG. 20-26 Jules Hardouin-Mansart, Charles Le Brun, and André Le Nôtre, aerial view of the palace and gardens (looking northwest), Versailles, France, begun 1669.

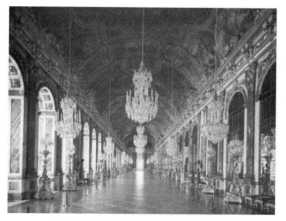

FIG. 20-27 Jules Hardouin-Mansart and Charles Le Brun, Galerie des Glaces (Hall of Mirrors), palace of Versailles, Versailles, France, ca. 1680.

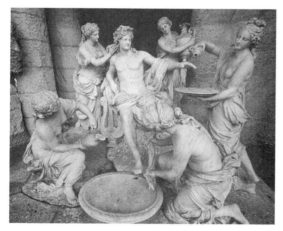

FIG. 20-28 François Girardon and Thomas Regnaudin, *Apollo Attended by the Nymphs*, Grotto of Thetis, Park of Versailles, Versailles, France, ca. 1666–1672. Marble, life-size.

119

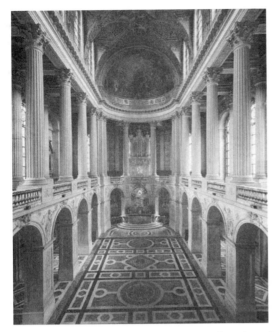

FIG. 20-29 JULES HARDOUIN-MANSART, interior of the Royal Chapel, with ceiling decorations by ANTOINE COYPEL, palace of Versailles, Versailles, France, 1698–1710.

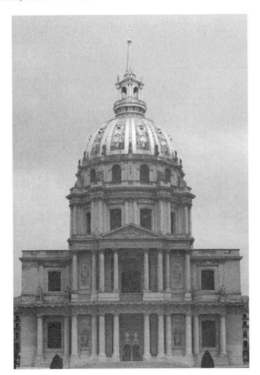

FIG. 20-30 JULES HARDOUIN-MANSART, Église du Dôme (looking north), Church of the Invalides, Paris, France, 1676–1706.

120

FIG. 20-31 NICOLAS POUSSIN, *Et in Arcadia Ego*, ca. 1655. Oil on canvas, 2′ 10″ × 4′. Musée du Louvre, Paris.

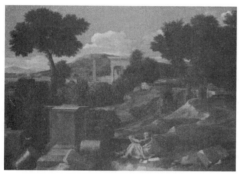

FIG. 20-32 NICOLAS POUSSIN, *Landscape with Saint John on Patmos*, 1640. Oil on canvas, 3′ 3 1/2″ × 4′ 5 5/8″. Art Institute of Chicago, Chicago (A. A. Munger Collection).

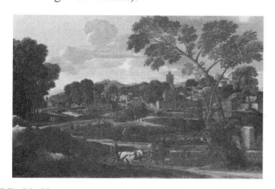

FIG. 20-32A POUSSIN, *Burial of Phocion*, 1648.

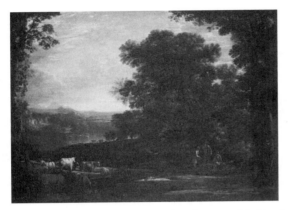

FIG. 20-33 CLAUDE LORRAIN, *Landscape with Cattle and Peasants*, 1629. Oil on canvas, 3′ 6″ × 4′ 10 1/2″. Philadelphia Museum of Art, Philadelphia (George W. Elkins Collection).

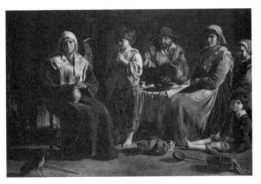

FIG. 20-34 LOUIS LE NATIN, *Family of Country People*, ca 1640. Oil on canvas, 3′ 8″ × 5′ 2″. Musée du Louvre, Paris.

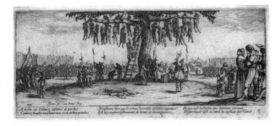

FIG. 20-35 JACQUES CALLOT, *Hanging Tree*, from the *Miseries of War* series, 1629–1633. Etching, 3 3/4″ × 7 1/4″. Biliothèque Nationale, Paris.

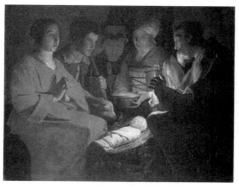

FIG. 20-36 GEORGES DE LA TOUR, *Adoration of the Shepherds*, 1645–1650. Oil on canvas, 3′ 6″ × 4′ 6″. Musée du Louvre, Paris.

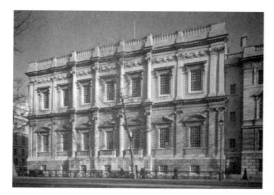

FIG. 20-37 INIGO JONES, Banqueting House (looking northeast), Whitehall, London, England, 1619–1622.

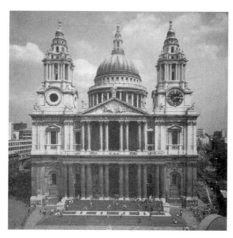

FIG. 20-38 SIR CHRISTOPHER WREN, west facade of Saint Paul's Cathedral, London, England, 1675–1710.

Chapter 21

Rococo to Neoclassicism:
The 18th Century in Europe and America

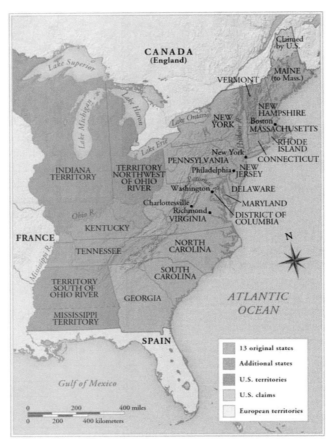

MAP 21-1 The United States in 1800.

FIG. 21-01 JOSEPH WRIGHT OF DERBY, *A Philosopher Giving a Lecture at the Orrery*, ca. 173–1765. Oil on canvas, 4′ 10″ × 6′ 8″. Derby Museums and Art Gallery, Derby.

FIG. 21-01A VANBRUGH and HAWKSMOOR, Blenheim Palace, 1705–1725.

FIG. 21-02 GERMAIN BOFFRAND, Salon de la Princesse, with paintings by CHARLES-JOSEPH NATOIRE and sculptures by JEAN-BAPTISTE LEMOYNE, Hôtel de Soubise, Paris, France, 1737–1740.

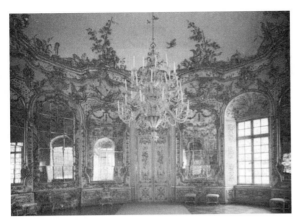

FIG. 21-03 FRANÇOIS DE CUVILLIÉS, Hall of Mirrors, the Amalienburg, Nymphenburg Palace park, Munich, Germany, early 18th century.

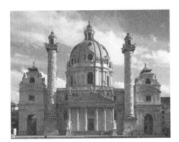

FIG. 21-03A FISCHER VON ERLACH, Karlskirche, Vienna, 1716–1737.

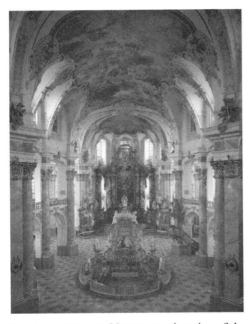

FIG. 21-04 BALTHASAR NEUMANN, interior of the pilgrimage church of Vierzehnheiligen (looking east), near Staffelstein, Germany, 1743–1772.

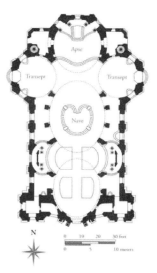

FIG. 21-05 Balthasar Neumann, plan of the pilgrimage church of Vierzehnheiligen, near Staffelstein, Germany, 1743–1772.

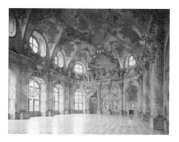

FIG. 21-05A Neumann, Kaisersaal, Wurzburg, 1719–1744.

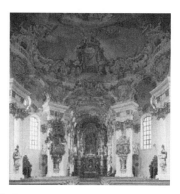

FIG. 21-05B Zimmermann, Wieskirche, Füssen, 1745–1754.

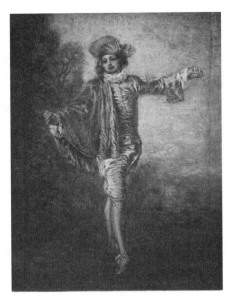

FIG. 21-06 ANTOINE WATTEAU, *L'Indifférent*, ca. 1716. Oil on canvas, 10″ × 7″. Musée du Louvre, Paris.

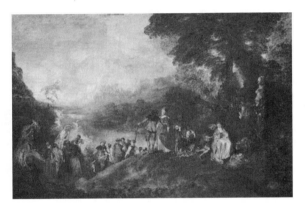

FIG. 21-07 ANTOINE WATTEAU, *Pilgrimage to Cythera*, 1717. Oil on canvas, 4′ 3″ × 6′ 4 1/2″. Musée du Louvre, Paris.

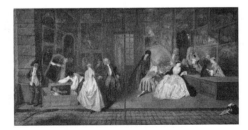

FIG. 21-07A WATTEAU, *Signboard of Gersaint*, 1721.

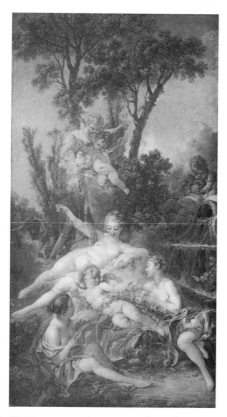

FIG. 21-08 FRANÇOIS BOUCHER, *Cupid a Captive*, 1754. Oil on canvas, 5′ 6″ × 2′ 10″. Wallace Collection, London.

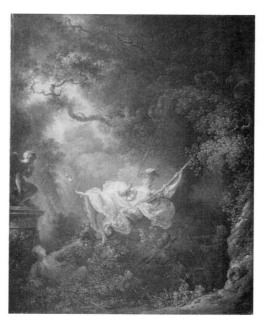

FIG. 21-09 JEAN-HONORÉ FRAGONARD, *The Swing*, 1766. Oil on canvas, 2′ 8 5/8″ × 2′ 2″. Wallace Collection, London.

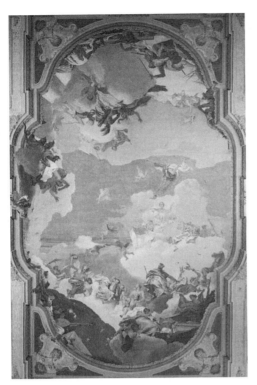

FIG. 21-10 GIAMBATTISTA TIEPOLO, *Apotheosis of the Pisani Family*, ceiling painting in the Villa Pisani, Stra, Italy, 1761–1762. Fresco, 77′ 1″ × 44′ 3″.

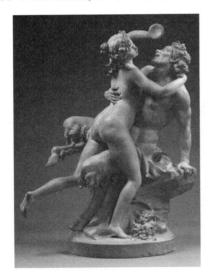

FIG. 21-11 CLODION, *Nymph and Satyr Carousing*, ca. 1780–1790. Terracotta, 1′ 11 1/4″ high. Metropolitan Museum of Art, New York (bequest of Benjamin Altman, 1913).

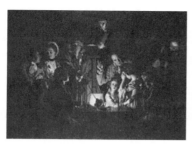

FIG. 21-11A WRIGHT OF DERBY, *Experiment on a Bird*, 1768.

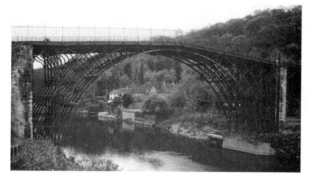

FIG. 21-12 ABRAHAM DARBY III and THOMAS F. PRITCHARD, iron bridge (looking northwest), Coalbrookdale, England, 1776–1779.

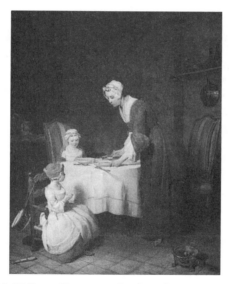

FIG. 21-13 JEAN-BAPTISTE-SIMÉON CHARDIN, *Saying Grace*, 1740. Oil on canvas, 1′ 7″ × 1′ 3″. Musée du Louvre, Paris.

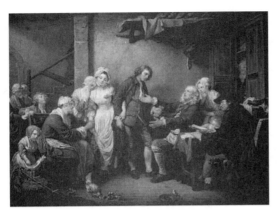

FIG. 21-14 Jean-Baptiste Greuze, *Village Bride*, 1761. Oil on canvas, 3′ × 3′ 10 1/2″.
Musée du Louvre, Paris.

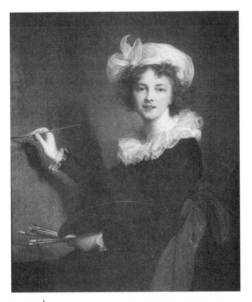

FIG. 21-15 Élisabeth-Louise Vigée-Lebrun, *Self-Portrait*, 1790. Oil on canvas, 8′ 4″ × 6′ 9″.
Galleria degli Uffizi, Florence.

FIG. 21-15A Vigée-Lebrun, *Marie Antoinette*, 1787.

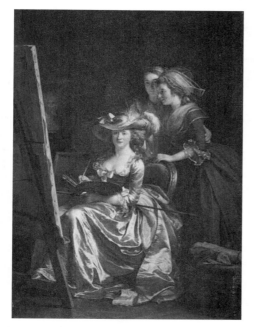

FIG. 21-16 ADÉLAÏDE LABILLE-GUIARD, *Self-Portrait with Two Pupils*, 1785. Oil on canvas, 6′ 11″ × 4′ 11 1/2″. Metropolitan Museum of Art, New York (gift of Julia A. Berwind, 1953).

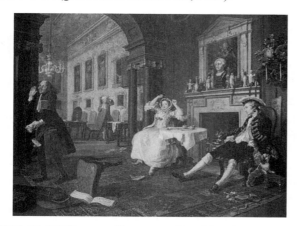

FIG. 21-17 WILLIAM HOGARTH, *Breakfast Scene*, from *Marriage à la Mode*, ca. 1745. Oil on canvas, 2′ 4″ × 3′. National Gallery, London.

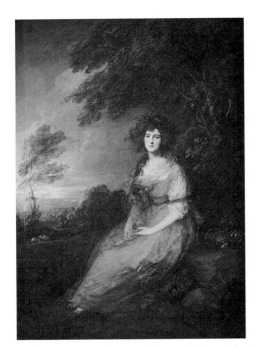

FIG. 21-18 THOMAS GAINSBOROUGH, *Mrs. Richard Brinsley Sheridan*, 1787. Oil on canvas, 7′ 2 5/8″ × 5′ 5/8″. National Gallery of Art, Washington, D.C. (Andrew W. Mellon Collection).

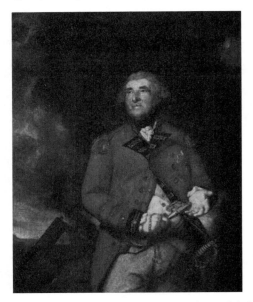

FIG. 21-19 SIR JOSHUA REYNOLDS, *Lord Heathfield*, 1787. Oil on canvas, 4′ 8″ × 3′ 9″. National Gallery, London.

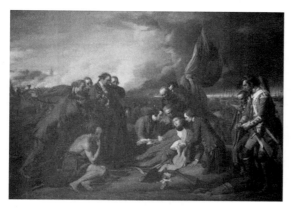

FIG. 21-20 BENJAMIN WEST, *Death of General Wolfe*, 1771. Oil on canvas, 4′ 11 1/2″ × 7′. National Gallery of Canada, Ottawa (gift of the Duke of Westminster, 1918).

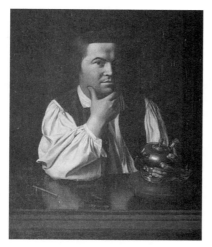

FIG. 21-21 JOHN SINGLETON COPLEY, *Portrait of Paul Revere*, ca. 1768–1770. Oil on canvas, 2′ 11 1/8″ × 2′ 4″. Museum of Fine Arts, Boston (gift of Joseph W., William B., and Edward H. R. Revere).

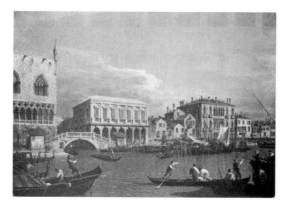

FIG. 21-22 ANTONIO CANALETTO, *Riva degli Schiavoni, Venice*, ca. 1735–1740. Oil on canvas, 1′ 6 1/2″ × 2′ 7/8″. Toledo Museum of Art, Toledo.

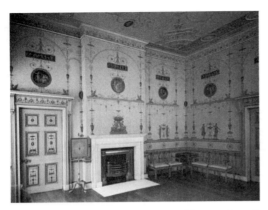

FIG. 21-23 ROBERT ADAM, Etruscan Room, Osterley Park House, Middlesex, England, begun 1761. Reconstructed in the Victoria & Albert Museum, London.

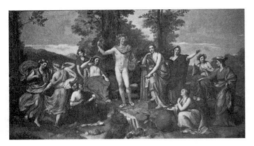

FIG. 21-23A MENGS, *Parnassus*, 1761.

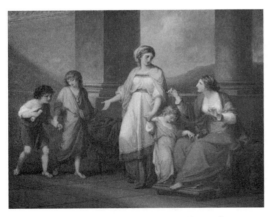

FIG. 21-24 ANGELICA KAUFFMANN, *Cornelia Presenting Her Children as Her Treasures*, or *Mother of the Gracchi*, ca. 1785. Oil on canvas, 3′ 4″ × 4′ 2″. Virginia Museum of Fine Arts, Richmond (Adolph D. and Wilkins C. Williams Fund).

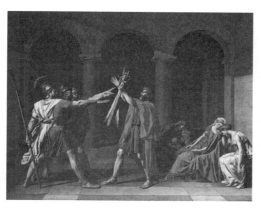

FIG. 21-25 JACQUES-LOUIS DAVID, *Oath of the Horatii*, 1784. Oil on canvas, 10′ 10″ × 13′ 11″. Musée du Louvre, Paris.

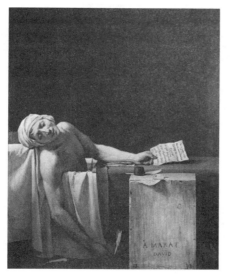

FIG. 21-26 JACQUES-LOUIS DAVID, *Death of Marat*, 1793. Oil on canvas, 5′ 5″ × 4′ 2 1/2″. Musée Royaux des Beaux-Arts de Belgique, Brussels.

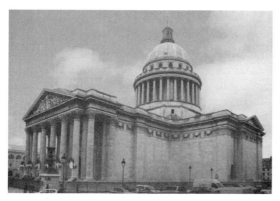

FIG. 21-27 JACQUES-GERMAIN SOUFFLOT, Panthéon (Sainte-Geneviève; looking northeast), Paris, France, 1755–1792.

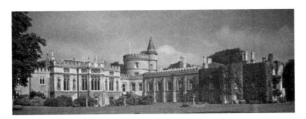

FIG. 21-27A WALPOLE, Strawberry Hill, Twickenham, 1749–1777.

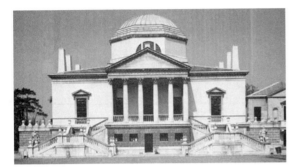

FIG. 21-28 RICHARD BOYLE and WILLIAM KENT, Chiswick House (looking northwest), near London, England, begun 1725.

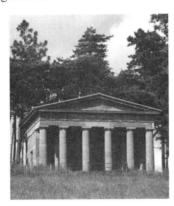

FIG. 21-28A STUART, Doric Protico, Hagley Park, 1758.

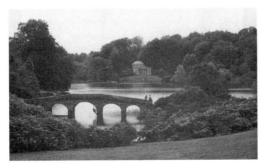

FIG. 21-29 HENRY FLITCROFT and HENRY HOARE, the park at Stourhead, England, 1743–1765.

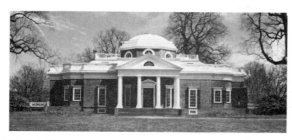

FIG. 21-30 THOMAS JEFFERSON, Monticello, Charlottesville, Virginia, 1770–1806.

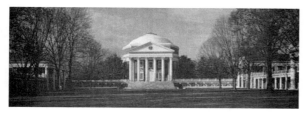

FIG. 21-31 THOMAS JEFFERSON, Rotunda and Lawn (looking north), University of Virginia, Charlottesville, Virginia, 1819–1826.

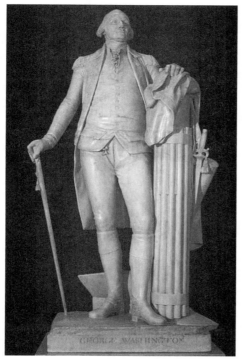

FIG. 21-32 JEAN-ANTOINE HOUDON, *George Washington*, 1788–1792. Marble, 6′ 2″ high. State Capitol, Richmond.

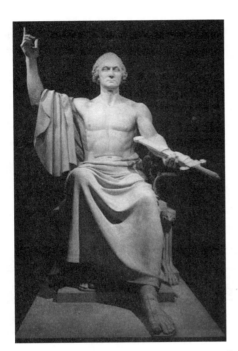

FIG. 21-33 HORATIO GREENOUGH, *George Washington*, 1840. Marble, 11′ 4″ high. Smithsonian American Art Museum, Washington, D.C.

Chapter 22

Romanticism, Realism, Photography: Europe and America 1800 to 1870

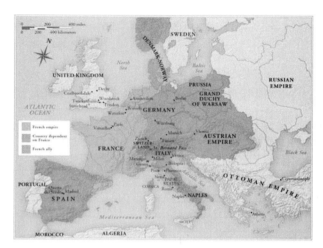

Map 22-1 The Napoleonic Empire in 1815.

Map 22-2 Europe around 1850.

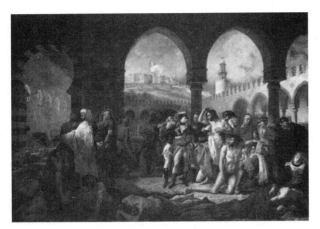

FIG. 22-01 ANTOINE-JEAN GROS, *Napoleon at the Plague House at Jaffa*, 1804. Oil on canvas, 17′5″ × 23′7″. Musée du Louvre, Paris.

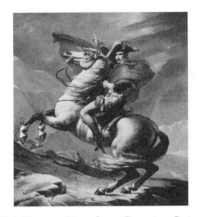

FIG. 22-01A DAVID, *Napoleon Crossing Saint-Bernard*, 1800–1801.

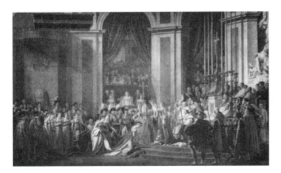

FIG. 22-02 JACQUES-LOUIS DAVID, *Coronation of Napoleon,* 1805–1808. Oil on canvas, 20′ 4 1/2″ × 32′ 1 3/4″. Musée du Louvre, Paris.

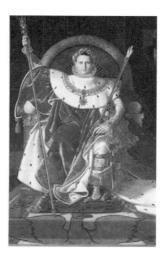

FIG. 22-02A INGRES, *Napoleon on His Imperial Throne*, 1806.

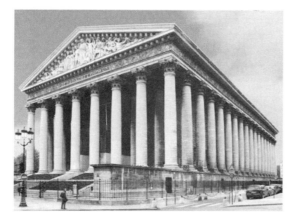

FIG. 22-03 PIERRE VIGNON, La Madeleine, Paris, France, 1807–1842.

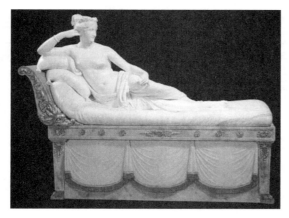

FIG. 22-04 ANTONIO CANOVA, *Pauline Borghese as Venus,* 1808. Marble, 6′ 7″ long. Galleria Borghese, Rome.

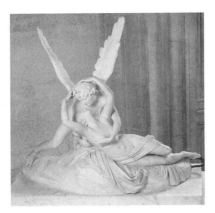

FIG. 22-04A CANOVA, *Cupid and Psyche*, 1787–1793.

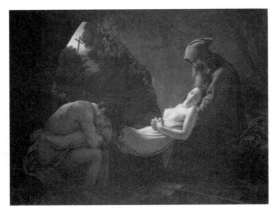

FIG. 22-05 ANNE-LOUIS GIRODET-TRIOSON, *Burial of Atala,* 1808. Oil on canvas, 6′ 11″ × 8′ 9″. Musée du Louvre, Paris.

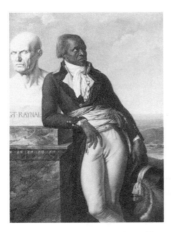

FIG. 22-05A GIRODET-TRIOSON, *Jean-Baptiste Belley*, 1797.

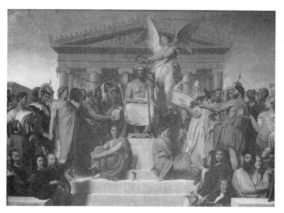

FIG. 22-06 JEAN-AUGUSTE-DOMINIQUE INGRES,
Apotheosis of Homer, 1827. Oil on canvas,
12′ 8″ × 16′ 10 3/4″. Musée du Louvre, Paris.

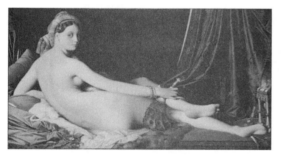

FIG. 22-07 JEAN-AUGUSTE-DOMINIQUE INGRES, *Grande
Odalisque,* 1814. Oil on canvas, 2′ 11 7/8″ × 5′ 4″.
Musée du Louvre, Paris.

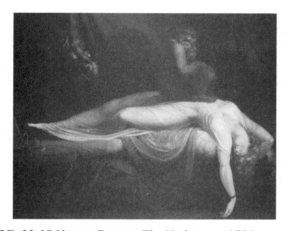

FIG. 22-08 HENRY FUSELI, *The Nightmare,* 1781.
Oil on canvas, 3′ 3 3/4″ × 4′ 1 1/2″. Detroit Institute
of the Arts (Founders Society Purchase with funds
from Mr. and Mrs. Bert L. Smokler and Mr. and
Mrs. Lawrence A. Fleishman).

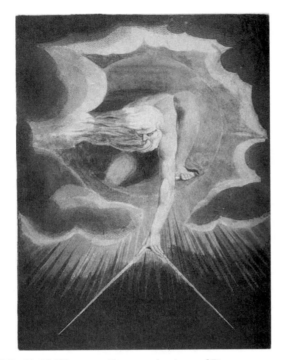

FIG. 22-09 WILLIAM BLAKE, *Ancient of Days,* frontispiece of *Europe: A Prophecy,* 1794. Metal relief etching, hand colored, 9 1/2″ × 6 3/4″. Pierpont Morgan Library, New York.

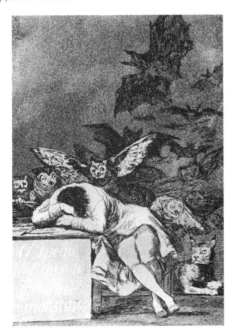

FIG. 22-10 FRANCISCO GOYA, *The Sleep of Reason Produces Monsters,* from *Los Caprichos,* ca. 1798. Etching and aquatint, 8 1/2″ × 5 7/8″. Metropolitan Museum of Art, New York (gift of M. Knoedler & Co., 1918).

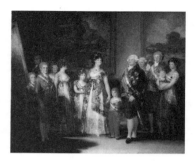

FIG. 22-10A GOYA, *Family of Charles IV*, 1800.

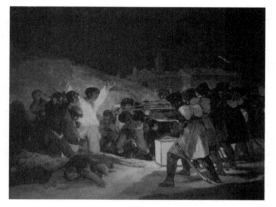

FIG. 22-11 FRANCISCO GOYA, *Third of May, 1808,* 1814–1815. Oil on canvas, 8′ 9″ × 13′ 4″. Museo del Prado, Madrid.

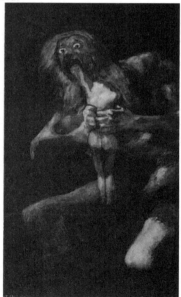

FIG. 22-12 FRANCISCO GOYA, *Saturn Devouring One of His Children,* 1819–1823. Fresco, later detached and mounted on canvas, 4′ 9 1/8″ × 2′ 8 5/8″. Museo del Prado, Madrid.

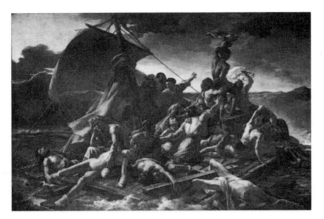

FIG. 22-13 THÉODORE GÉRICAULT, *Raft of the Medusa,* 1818–1819. Oil on canvas, 16′ 1″ × 23′ 6″. Musée du Louvre, Paris.

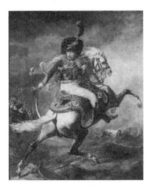

FIG. 22-13A GÉRICAULT, *Charging Chasseur*, 1812.

FIG. 22-14 THÉODORE GÉRICAULT, *Insane Woman,* 1822–1823. Oil on canvas, 2′ 4″ × 1′ 9″. Musée des Beaux-Arts, Lyons.

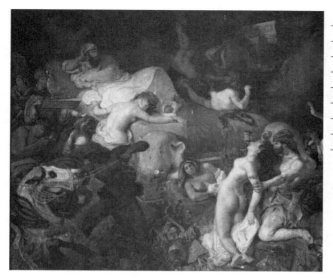

FIG. 22-15 EUGÈNE DELACROIX, *Death of Sardanapalus,* 1827. Oil on canvas, 12′ 1 1/2″ × 16′ 2 7/8″. Musée du Louvre, Paris.

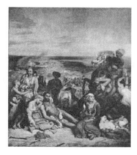

FIG. 22-15A DELACROUX, *Massacre at Chios*, 1822–1824.

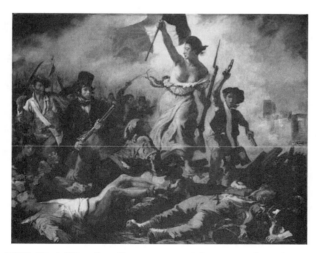

FIG. 22-16 EUGÈNE DELACROIX, *Liberty Leading the People,* 1830. Oil on canvas, 8′ 6″ × 10′ 8″. Musée du Louvre, Paris.

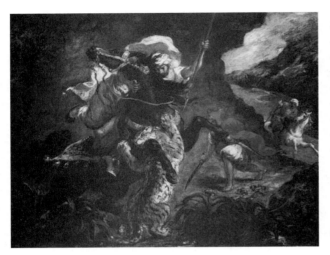

FIG. 22-17 EUGÈNE DELACROIX, *Tiger Hunt,* 1854. Oil on canvas, 2′ 5″ × 3′. Musée d'Orsay, Paris.

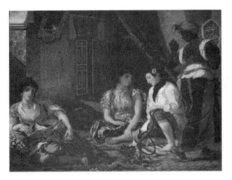

FIG. 22-17A DELACROUIX, *Women of Algiers,* 1834.

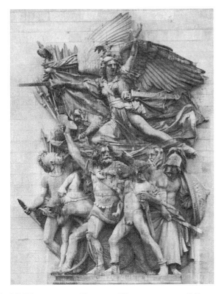

FIG. 22-18 FRANÇOIS RUDE, *Departure of the Volunteers of 1792* (*La Marseillaise*), Arc de Triomphe, Paris, France, 1833–1836. Limestone, 41′ 8″ high.

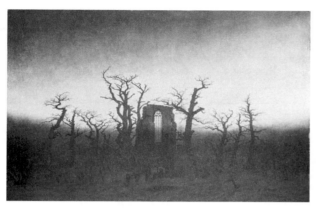

FIG. 22-19 CASPAR DAVID FRIEDRICH, *Abbey in the Oak Forest,* 1810. Oil on canvas, 4′ × 5′ 8 1/2″. Nationalgalerie, Staatliche Museen zu Berlin, Berlin.

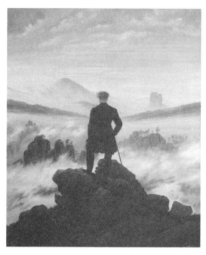

FIG. 22-20 CASPAR DAVID FRIEDRICH, *Wanderer above a Sea of Mist*, 1817–1818. Oil on canvas, 3′ 1 3/4″ × 2′ 5 3/8″. Hamburger Kunsthalle, Hamburg.

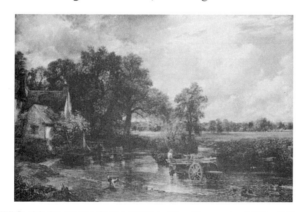

FIG. 22-21 JOHN CONSTABLE, *The Haywain,* 1821. Oil on canvas, 4′ 3 1/4″ × 6′ 1″. National Gallery, London.

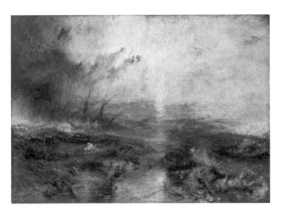

FIG. 22-22 JOSEPH MALLORD WILLIAM TURNER, *The Slave Ship* (*Slavers Throwing Overboard the Dead and Dying, Typhoon Coming On*), 1840. Oil on canvas, 2′ 11 1/4″ × 4′. Museum of Fine Arts, Boston (Henry Lillie Pierce Fund).

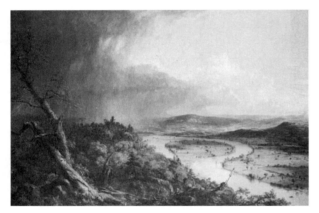

FIG. 22-23 THOMAS COLE, *The Oxbow* (*View from Mount Holyoke, Northampton, Massachusetts, after a Thunderstorm*), 1836. Oil on canvas, 4′ 3 1/2″ × 6′ 4″. Metropolitan Museum of Art, New York (gift of Mrs. Russell Sage, 1908).

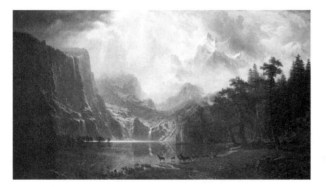

FIG. 22-24 ALBERT BIERSTADT, *Among the Sierra Nevada Mountains, California,* 1868. Oil on canvas, 6′ × 10′. National Museum of American Art, Smithsonian Institution, Washington, D.C.

FIG. 22-25 FREDERIC EDWIN CHURCH, *Twilight in the Wilderness,* 1860s. Oil on canvas, 3′ 4″ × 5′ 4″. Cleveland Museum of Art, Cleveland (Mr. and Mrs. William H. Marlatt Fund).

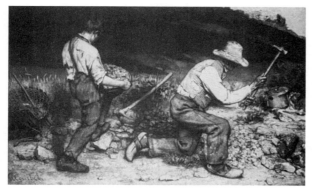

FIG. 22-26 GUSTAVE COURBET, *The Stone Breakers,* 1849. Oil on canvas, 5′ 3″ × 8′ 6″. Formerly Gemäldegalerie, Dresden (destroyed in 1945).

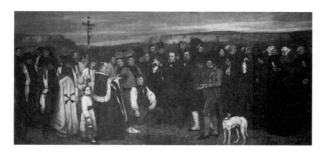

FIG. 22-27 GUSTAVE COURBET, *Burial at Ornans,* 1849. Oil on canvas, 10′ 3 1/2″ × 21′ 9 1/2″. Musée d'Orsay, Paris.

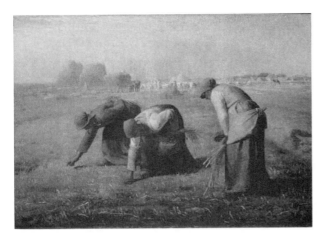

FIG. 22-28 JEAN-FRANÇOIS MILLET, *The Gleaners,*
1857. Oil on canvas, 2′ 9″ × 3′ 8″. Musée d'Orsay, Paris.

FIG. 22-29 HONORÉ DAUMIER, *Rue Transnonain,* 1834.
Lithograph, 1′ × 1′ 5 1/2″. Philadelphia Museum of Art,
Philadelphia (bequest of Fiske and Marie Kimball).

FIG. 22-30 HONORÉ DAUMIER, *Third-Class Carriage,*
ca. 1862. Oil on canvas, 2′ 1 3/4″ × 2′ 11 1/2″.
Metropolitan Museum of Art, New York (H. O.
Havemeyer Collection, bequest of Mrs. H. O.
Havemeyer, 1929).

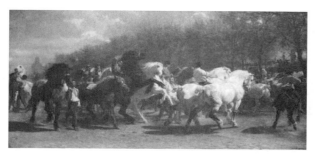

FIG. 22-31 ROSA BONHEUR, *The Horse Fair,*
1853–1855. Oil on canvas, 8′ 1/4″ × 16′ 7 1/2″.
Metropolitan Museum of Art, New York (gift of
Cornelius Vanderbilt, 1887).

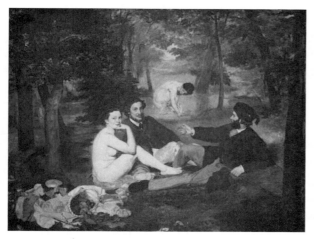

FIG. 22-32 ÉDOUARD MANET, *Le Déjeuner sur l'Herbe*
(*Luncheon on the Grass*), 1863. Oil on canvas,
7′ × 8′ 8″. Musée d'Orsay, Paris.

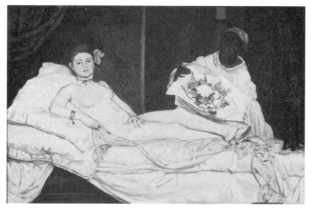

FIG. 22-33 ÉDOUARD MANET, *Olympia,* 1863.
Oil on canvas, 4′ 3″ × 6′ 2 1/4″. Musée d'Orsay, Paris.

FIG. 22-33A BOUGUEREAU, *Nymphs and a Satyr*, 1873.

FIG. 22-34 WILHELM LEIBL, *Three Women in a Village Church,* 1878–1882. Oil on canvas, 2′ 5″ × 2′ 1″. Hamburger, Kunsthalle, Hamburg.

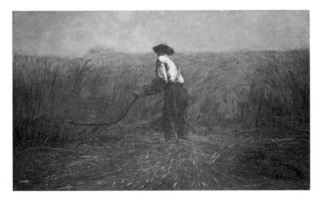

FIG. 22-35 WINSLOW HOMER, *Veteran in a New Field,* 1865. Oil on canvas, 2′ 1/8″ × 3′ 2 1/8″. Metropolitan Museum of Art, New York (bequest of Miss Adelaide Milton de Groot, 1967).

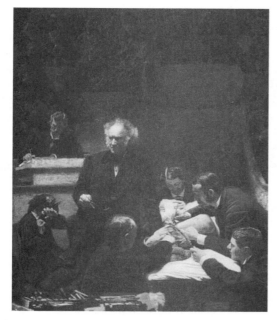

FIG. 22-36 THOMAS EAKINS, *The Gross Clinic,* 1875. Oil on canvas, 8′ × 6′ 6″. Philadelphia Museum of Art, Philadelphia.

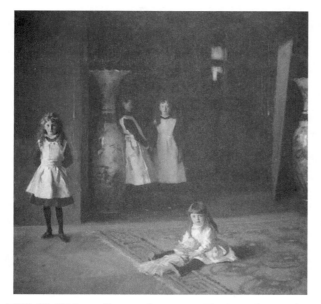

FIG. 22-37 JOHN SINGER SARGENT, *The Daughters of Edward Darley Boit,* 1882. Oil on canvas, 7′ 3 3/8″ × 7′ 3 5/8″. Museum of Fine Arts, Boston (gift of Mary Louisa Boit, Florence D. Boit, Jane Hubbard Boit, and Julia Overing Boit, in memory of their father, Edward Darley Boit).

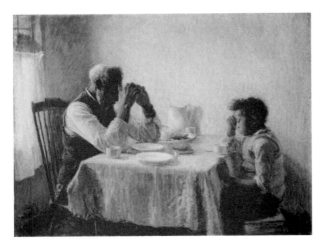

FIG. 22-38 HENRY OSSAWA TANNER, *The Thankful Poor,* 1894. Oil on canvas, 2′ 11 1/2″ × 3′ 8 1/4″. Collection of William H. and Camille Cosby.

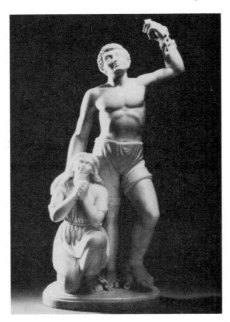

FIG. 22-39 EDMONIA LEWIS, *Forever Free,* 1867. Marble, 3′ 5 1/4″ high. James A. Porter Gallery of Afro-American Art, Howard University, Washington, D.C.

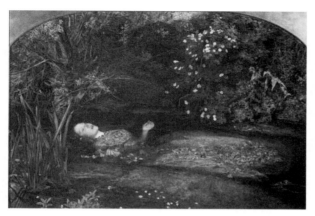

FIG. 22-40 JOHN EVERETT MILLAIS, *Ophelia,* 1852. Oil on canvas, 2′ 6″ × 3′ 8″. Tate Gallery, London.

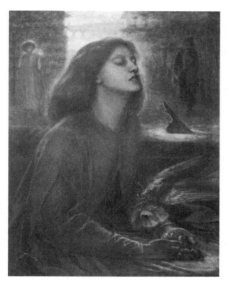

FIG. 22-41 DANTE GABRIEL ROSSETTI, *Beata Beatrix,* ca. 1863. Oil on canvas, 2′ 10″ × 2′ 2″. Tate Gallery, London.

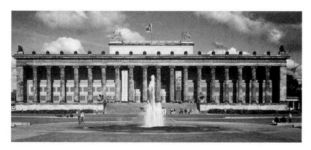

FIG. 22-42 KARL FRIEDRICH SCHINKEL, Altes Museum, Berlin, Germany, 1822–1830.

159

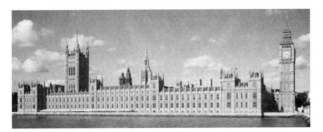

FIG. 22-43 CHARLES BARRY and AUGUSTUS WELBY NORTHMORE PUGIN, Houses of Parliament, London, England, designed 1835.

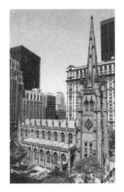

FIG. 22-43A UPJOHN, Trinity Church, New York, 1841–1852.

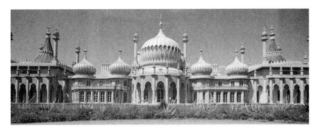

FIG. 22-44 JOHN NASH, Royal Pavilion, Brighton, England, 1815–1818.

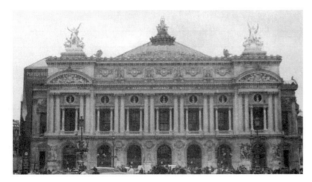

FIG. 22-45 CHARLES GERNIER, Opéra (looking north), Paris, France, 1861–1874.

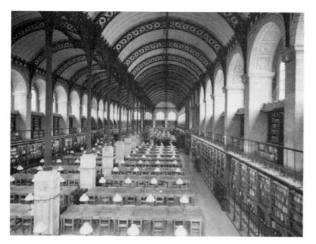

FIG. 22-46 HENRI LABROUSTE, reading room of the Bibliothèque Sainte-Geneviève, Paris, France, 1843–1850.

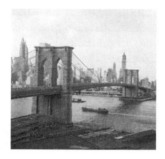

FIG. 22-46A ROEBLING, Brooklyn Bridge, 1867–1883.

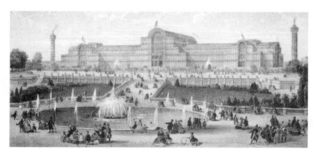

FIG. 22-47 JOSEPH PAXTON, Crystal Palace, London, England, 1850–1851; enlarged and relocated at Sydenham, England, 1852–1854. Detail of a color lithograph by ACHILLE-LOUIS MARTINET, ca. 1862. Private collection.

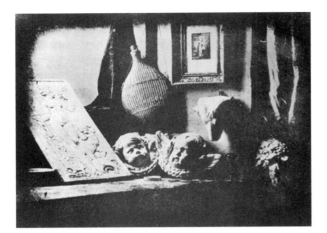

FIG. 22-48 LOUIS-JACQUES-MANDÉ DAGUERRE, *Still Life in Studio,* 1837. Daguerreotype, 6 1/4″ × 8 1/4″. Société Française de Photographie, Paris.

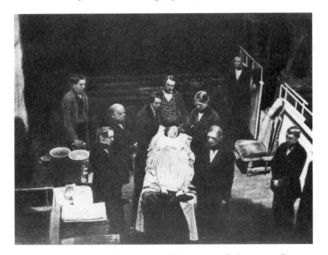

FIG. 22-49 JOSIAH JOHNSON HAWES and ALBERT SANDS SOUTHWORTH, *Early Operation under Ether, Massachusetts General Hospital,* ca. 1847. Daguerreotype, 6 1/2″ × 8 1/2″. Massachusetts General Hospital Archives and Special Collections, Boston.

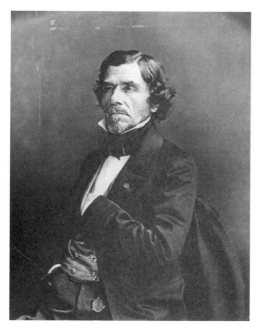

FIG. 22-50 NADAR, *Eugène Delacroix*, ca. 1855. Modern print, 8 1/2″ × 6 2/3″, from the original negative. Bibliothèque Nationale, Paris.

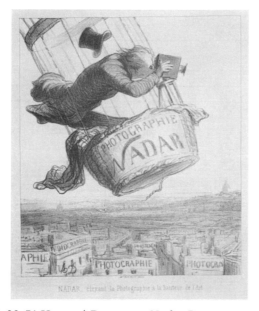

FIG. 22-51 HONORÉ DAUMIER, *Nadar Raising Photography to the Height of Art*, 1862. Lithograph, 10 3/4″ × 8 3/4″. Museum of Fine Arts, Boston.

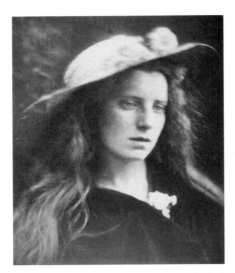

FIG. 22-52 JULIA MARGARET CAMERON, *Ophelia, Study No. 2,* 1867. Albumen print, 1′ 1 ″ × 10 2/3″. George Eastman House, Rochester (gift of Eastman Kodak Company; formerly Gabriel Cromer Collection).

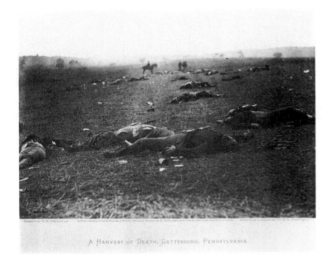

FIG. 22-53 TIMOTHY O'SULLIVAN, *A Harvest of Death, Gettysburg, Pennsylvania,* 1863. Negative by Timothy O'Sullivan. Albumen print by ALEXANDER GARDNER, 6 3/4″ × 8 3/4″. New York Public Library (Astor, Lenox and Tilden Foundations, Rare Books and Manuscript Division), New York.

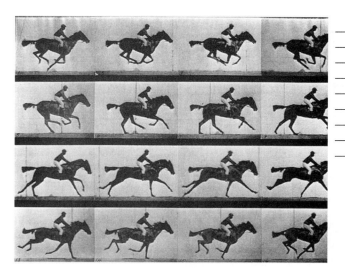

FIG. 22-54 EADWEARD MUYBRIDGE, *Horse Galloping,* 1878. Calotype print, 9″ × 12″. George Eastman House, Rochester.

Chapter 23

Impressionism, Post-Impressionism, Symbolism: Europe and America, 1870 to 1900

MAP 23-1 France around 1870.

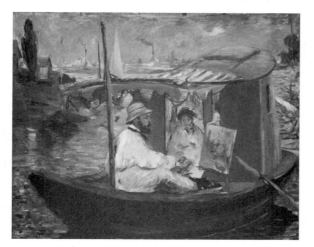

FIG. 23-01 ÉDOUARD MANET, *Claude Monet in His Studio Boat*, 1874. Oil on canvas, 2′8″ × 3′3 1/4″. Neue Pinakothek, Munich.

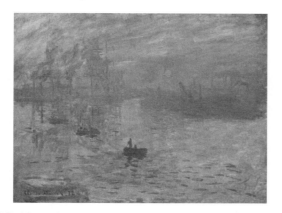

FIG. 23-02 CLAUDE MONET, *Impression: Sunrise,* 1872. Oil on canvas, 1′ 7 1/2″ × 2′ 1 1/2″. Musée Marmottan, Paris.

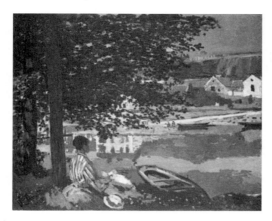

FIG. 23-02A MONET, *Bank of the Seine, Bennecourt,* 1868.

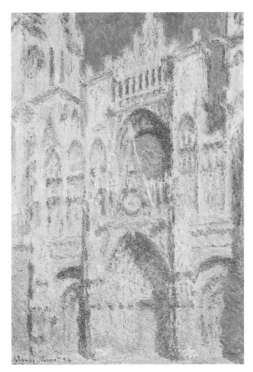

FIG. 23-03 CLAUDE MONET, *Rouen Cathedral: The Portal* (*in Sun*), 1894. Oil on canvas, 3′ 3 1/4″ × 2′ 1 7/8″. Metropolitan Museum of Art, New York (Theodore M. Davis Collection, bequest of Theodore M. Davis, 1915).

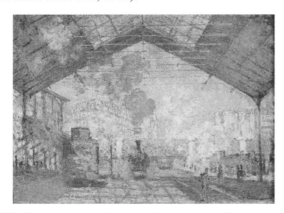

FIG. 23-04 CLAUDE MONET, *Saint-Lazare Train Station,* 1877. Oil on canvas, 2′ 5 3/4″ × 3′ 5″. Musée d'Orsay, Paris.

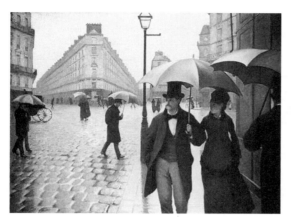

FIG. 23-05 GUSTAVE CAILLEBOTTE, *Paris: A Rainy Day,* 1877. Oil on canvas, 6′ 9″ × 9′ 9″. Art Institute of Chicago, Chicago (Worcester Fund).

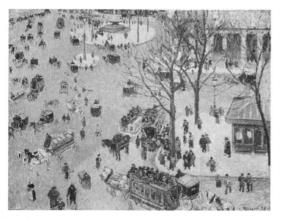

FIG. 23-06 CAMILLE PISSARRO, *La Place du Théâtre Français,* 1898. Oil on canvas, 2′ 4 1/2″ × 3′ 1/2″. Los Angeles County Museum of Art, Los Angeles (Mr. and Mrs. George Gard De Sylva Collection).

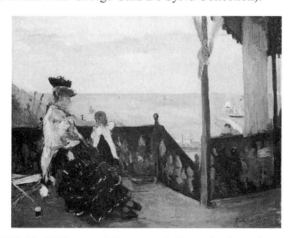

FIG. 23-07 BERTHE MORISOT, *Villa at the Seaside,* 1874. Oil on canvas, 1′ 7 3/4″ × 2′ 1/8″. Norton Simon Art Foundation, Los Angeles.

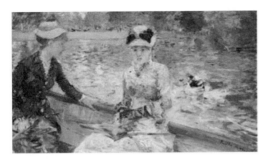

FIG. 23-07A MORISOT, *Summer's Day*, 1879.

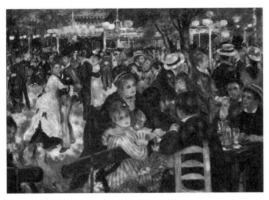

FIG. 23-08 PIERRE-AUGUSTE RENOIR, *Le Moulin de la Galette,* 1876. Oil on canvas, 4′ 3″ × 5′ 8″. Musée d'Orsay, Paris.

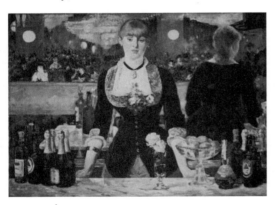

FIG. 23-09 ÉDOUARD MANET, *A Bar at the Folies-Bergère,* 1882. Oil on canvas, 3′ 1″ × 4′ 3″. Courtauld Insitute of Art Gallery, London.

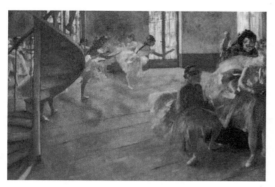

FIG. 23-10 EDGAR DEGAS, *The Rehearsal*, 1874. Oil on canvas, 1′ 11″ × 2′ 9″. Glasgow Art Galleries and Museum, Glasgow (Burrell Collection).

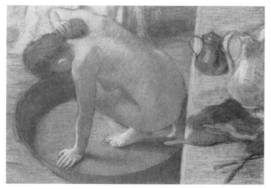

FIG. 23-11 EDGAR DEGAS, *The Tub*, 1886, Pastel, 1′ 11 1/2″ × 2′ 8 3/8″. Musée d'Orsay, Paris.

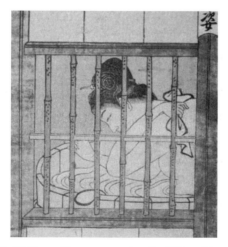

FIG. 23-12 TORII KIYONAGA, detail of *Two Women at the Bath*, ca. 1780. Color woodblock, full print 10 1/2″ × 7 1/2″, detail 3 3/4″ × 3 1/2″. Musée Guimet, Paris.

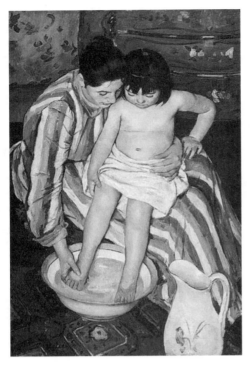

FIG. 23-13 MARY CASSATT, *The Bath,* ca. 1892.
Oil on canvas, 3′ 3″ × 2′ 2″. Art Institute of Chicago,
Chicago (Robert A. Walker Fund).

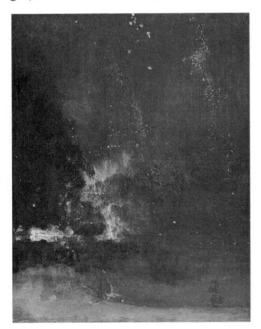

FIG. 23-14 JAMES ABBOTT MCNEILL WHISTLER,
Nocturne in Black and Gold (*The Falling Rocket*),
ca. 1875. Oil on panel, 1′11 5/8″ × 1′ 6 1/2″. Detroit
Institute of Arts, Detroit (gift of Dexter M. Ferry Jr.).

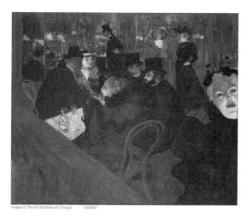

FIG. 23-15 HENRI DE TOULOUSE-LAUTREC, *At the Moulin Rouge,* 1892–1895. Oil on canvas, 4′ × 4′ 7″. Art Institute of Chicago, Chicago (Helen Birch Bartlett Memorial Collection).

FIG. 23-15A TOULOUSE-LAUTREC, *Jane Avril*, 1893.

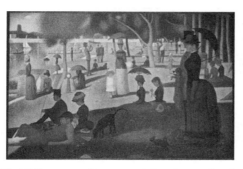

FIG. 23-16 GEORGES SEURAT, *A Sunday on La Grande Jatte,* 1884–1886. Oil on canvas, 6′ 9″ × 10′. Art Institute of Chicago, Chicago (Helen Birch Bartlett Memorial Collection, 1926).

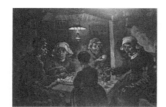

FIG. 23-16A VAN GOGH, *The Potato Eaters*, 1885.

173

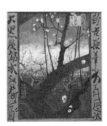

FIG. 23-16B VAN GOGH, *Flowering Plum Tree*, 1887.

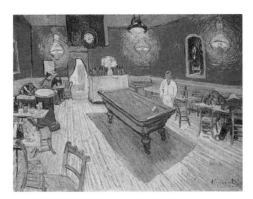

FIG. 23-17 VINCENT VAN GOGH, *Night Café,* 1888. Oil on canvas, 2′ 4 1/2″ × 3′. Yale University Art Gallery, New Haven (bequest of Stephen Carlton Clark).

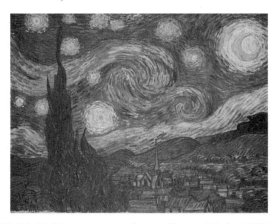

FIG. 23-18 VINCENT VAN GOGH, *Starry Night,* 1889. Oil on canvas, 2′ 5″ × 3′ 1/4″. Museum of Modern Art, New York (acquired through the Lillie P. Bliss Bequest).

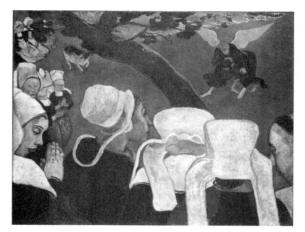

FIG. 23-19 PAUL GAUGUIN, *Vision after the Sermon* (*Jacob Wrestling with the Angel*), 1888. Oil on canvas, 2′ 4 3/4″ × 3′ 1/2″. National Gallery of Scotland, Edinburgh.

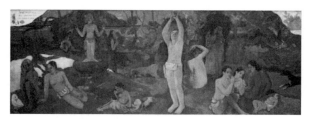

FIG. 23-20 PAUL GAUGUIN, *Where Do We Come From? What Are We? Where Are We Going?* 1897. Oil on canvas, 4′ 6 3/4″ × 12′ 3″. Museum of Fine Arts, Boston (Tompkins Collection).

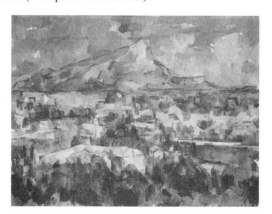

FIG. 23-21 PAUL CÉZANNE, *Mount Sainte-Victoire,* 1902–1904. Oil on canvas, 2′ 3 1/2″ × 2′ 11 1/4″. Philadelphia Museum of Art, Philadelphia (The George W. Elkins Collection).

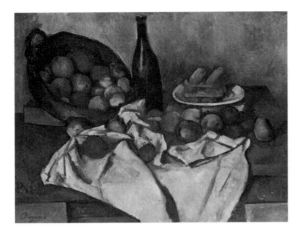

FIG. 23-22 PAUL CÉZANNE, *Basket of Apples,* ca. 1895. Oil on canvas, 2′ 3/8″ × 2′ 7″. Art Institute of Chicago, Chicago (Helen Birch Bartlett Memorial Collection, 1926).

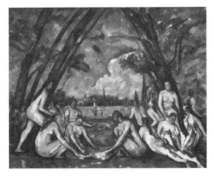

FIG. 23-22A CÉZANNE, *Large Bathers*, 1906.

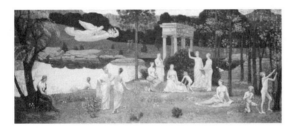

FIG. 23-23 PIERRE PUVIS DE CHAVANNES, *Sacred Grove,* 1884. Oil on canvas, 2′ 11 1/2″ × 6′ 10″. Art Institute of Chicago, Chicago (Potter Palmer Collection).

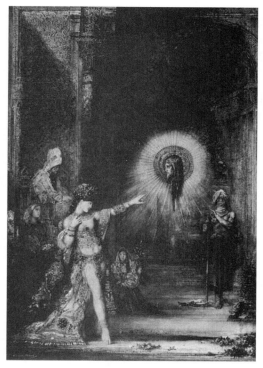

FIG. 23-24 GUSTAVE MOREAU, *The Apparition*, 1874–1876. Watercolor on paper, 3′ 5 3/4″ × 2′ 4 3/8″. Musée du Louvre, Paris.

FIG. 23-24A MOREAU, *Jupiter and Semele*, ca. 1875.

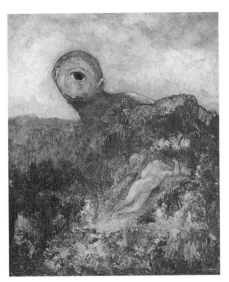

FIG. 23-25 ODILON REDON, *The Cyclops,* 1898. Oil on canvas, 2′ 1″ × 1′ 8″. Kröller-Müller Foundation, Otterlo.

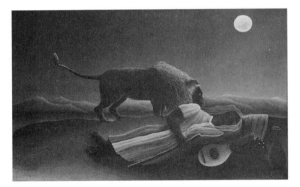

FIG. 23-26 HENRI ROUSSEAU, *Sleeping Gypsy,* 1897. Oil on canvas, 4′ 3″ × 6′ 7″. Museum of Modern Art, New York (gift of Mrs. Simon Guggenheim).

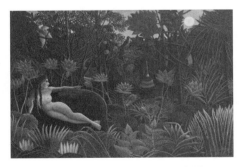

FIG. 23-26A ROUSSEAU, *The Dream*, 1910.

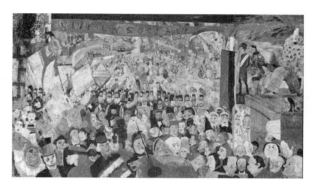

FIG. 23-27 JAMES ENSOR, *Christ's Entry into Brussels in 1889*, 1888. Oil on canvas, 8′ 3 1/2″ × 14′ 1 1/2″. J. Paul Getty Museum, Los Angeles.

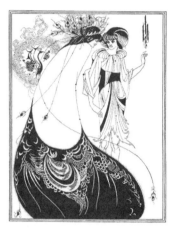

FIG. 23-27A BEARDSLEY, *The Peacock Skirt*, 1894.

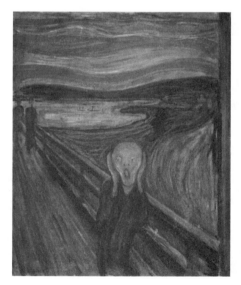

FIG. 23-28 EDVARD MUNCH, *The Scream,* 1893. Tempura and pastels on cardboard, 2′ 11 3/4″ × 2′ 5″. National Gallery, Oslo.

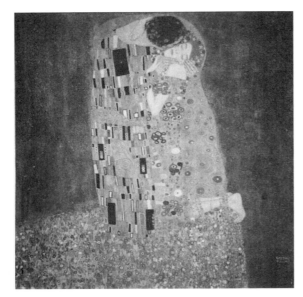

FIG. 23-29 GUSTAV KLIMT, *The Kiss,* 1907–1908.
Oil on canvas, 5′ 10 3/4″ × 5′ 10 3/4″. Österreichische
Galerie Belvedere, Vienna.

FIG. 23-30 GERTRUDE KÄSEBIER, *Blessed Art Thou
among Women,* 1899. Platinum print on Japanese tissue,
9 3/8″ × 5 1/2″. Museum of Modern Art, New York
(gift of Mrs. Hermine M. Turner).

FIG. 23-31 JEAN-BAPTISTE CARPEAUX, *Ugolino and His Children,* 1865–1867. Marble, 6′ 5″ high. Metropolitan Museum of Art, New York (Josephine Bay Paul and C. Michael Paul Foundation, Inc., and the Charles Ulrich and Josephine Bay Foundation, Inc., gifts, 1967).

FIG. 23-31A CARPEAUX, *The Dance*, 1867–1869.

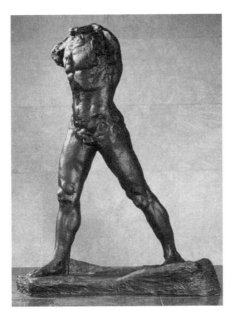

FIG. 23-32 Auguste Rodin, *Walking Man,* 1905. Bronze, 6′ 11 3/4″ high. Musée d'Orsay, Paris.

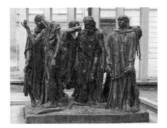

FIG. 23-32A Rodin, *Burghers of Calais*, 1884–1889.

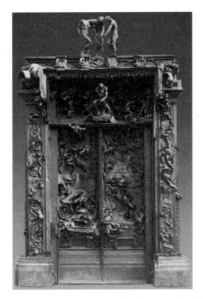

FIG. 23-33 Auguste Rodin, *The Gates of Hell*, 1880–1900. (cast in 1917). Bronze, 20′ 10″ × 13′ 1″. Musée Rodin, Paris.

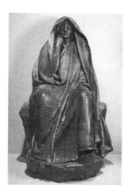

FIG. 23-33A Saint-Gaudens, *Adams Memorial*, 1886–1891.

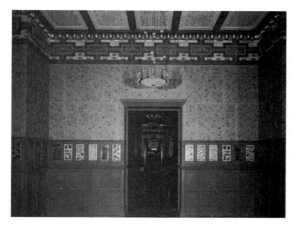

FIG. 23-34 William Morris, Green Dining Room, South Kensington Museum (now Victoria & Albert Museum), London, England, 1867.

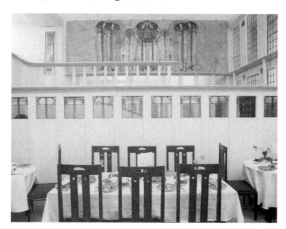

FIG. 23-35 Charles Rennie Mackintosh and Margaret Macdonald Mackintosh, Ladies' Luncheon Room, Ingram Street Tea Room, Glasgow, Scotland, 1900–1912. Reconstructed (1992–1995) in the Glasgow Art Galleries and Museum, Glasgow.

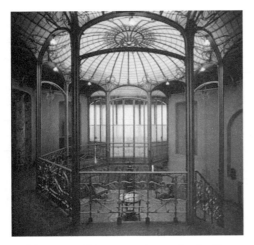

FIG. 23-36 VICTOR HORTA, staircase in the Van Eetvelde House, Brussels, 1895.

FIG. 23-36A HORTA, Tassel House, Brussels, 1892–1893.

FIG. 23-36B TIFFANY, water lily lamp, 1904–1915.

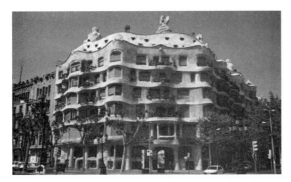

FIG. 23-37 ANTONIO GAUDI, Casa Milá (looking north), Barcelona, Spain, 1907.

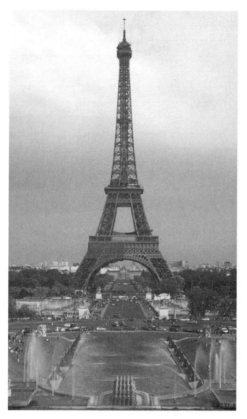

FIG. 23-38 ALEXANDRE-GUSTAVE EIFFEL, Eiffel Tower (looking southeast), Paris, France, 1889.

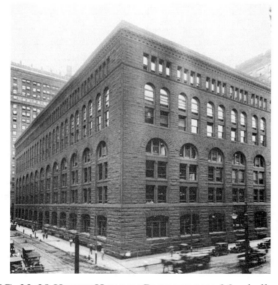

FIG. 23-39 HENRY HOBSON RICHARDSON, Marshall Field wholesale store, Chicago, 1885–1887 (demolished 1930).

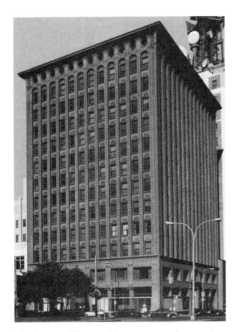

FIG. 23-40 LOUIS HENRY SULLIVAN, Guaranty (Prudential) Building (looking southwest), Buffalo, New York, 1894–1896.

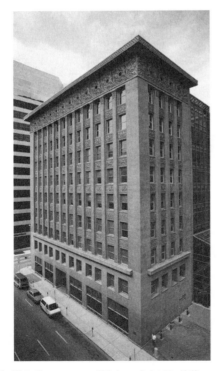

FIG. 23-40A SULLIVAN, Wainwright Building, St. Louis, 1890–1891.

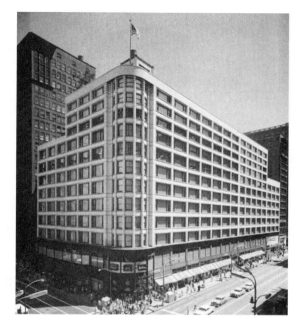

FIG. 23-41 Louis Henry Sullivan, Carson, Pirie, Scott Building (looking southeast), Chicago, 1899–1904.

Chapter 24

Modernism in Europe and America, 1900 to 1945

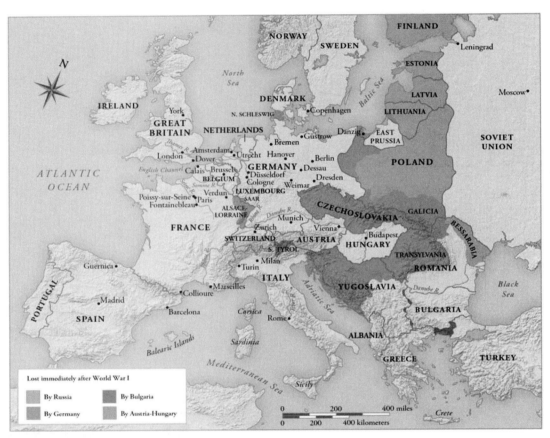

MAP 24-1 Europe at the end of World War I.

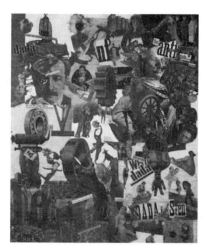

FIG. 24-01 HANNAH HÖCH, *Cut with the Kitchen Knife Dada through the Last Weimar Beer Belly Cultural Epoch of Germany*, 1919–1920. Photomontage, 3′ 9″ × 2′ 11 1/2″. Neue Nationalgalerie, Staaliche Museen zu Berlin, Berlin.

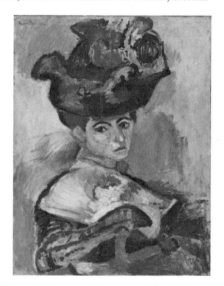

FIG. 24-02 HENRI MATISSE, *Woman with the Hat,* 1905. Oil on canvas, 2′ 7 3/4″ × 1′ 11 1/2″. San Francisco Museum of Modern Art, San Francisco (bequest of Elise S. Haas).

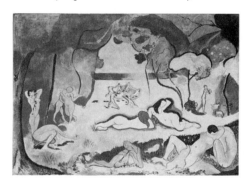

FIG. 24-02A MATISSE, *Le Bonheur de Vivre*, 1905–1906.

189

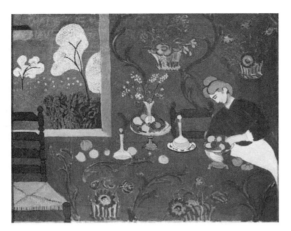

FIG. 24-03 HENRI MATISSE, *Red Room* (*Harmony in Red*), 1908–1909. Oil on canvas, 5′11″ × 8′1″. State Hermitage Museum, Saint Petersburg.

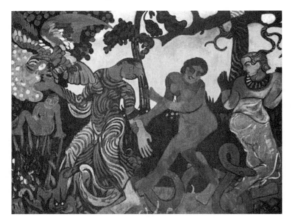

FIG. 24-04 ANDRÉ DERAIN, *The Dance,* 1906. Oil on canvas, 6′ 7/8″ × 6′ 10 1/4″. Fridart Foundation, London.

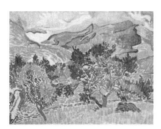

FIG. 24-04A DERAIN, *Mountains at Collioure,* 1905.

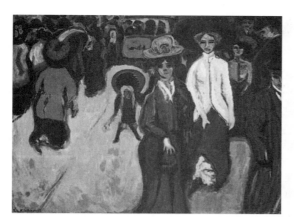

FIG. 24-05 ERNST LUDWIG KIRCHNER, *Street, Dresden,* 1908 (dated 1907). Oil on canvas, 4′ 11 1/4″ × 6′ 6 7/8″. Museum of Modern Art, New York.

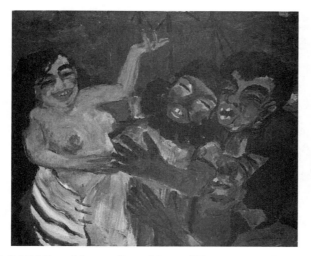

FIG. 24-06 EMIL NOLDE, *Saint Mary of Egypt among Sinners,* 1912. Left panel of a triptych, oil on canvas, 2′ 10″ × 3′ 3″. Hamburger Kunsthalle, Hamburg.

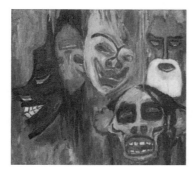

FIG. 24-06A NOLDE, *Masks,* 1911.

191

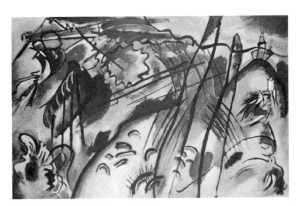

FIG. 24-07 Vassily Kandinsky, *Improvisation 28* (second version), 1912. Oil on canvas, 3′ 7 7/8″ × 5′ 3 7/8″. Solomon R. Guggenheim Museum, New York (gift of Solomon R. Guggenheim, 1937).

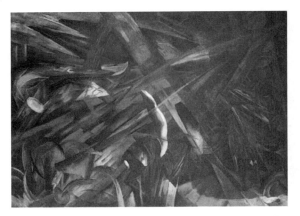

FIG. 24-08 Franz Marc, *Fate of the Animals,* 1913. Oil on canvas, 6′ 4 3/4″ × 8′ 9 1/2″. Kunstmuseum Basel, Basel.

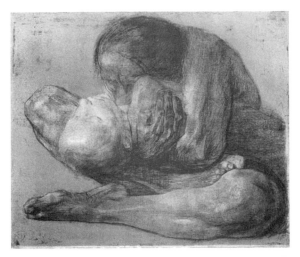

FIG. 24-09 Käthe Kollowitz, *Woman with Dead Child,* 1903. Etching and soft-ground etching, overprinted lithographically with a gold tone plate, 1′ 4 5/8″ × 1′ 7 1/8″. British Museum, London.

192

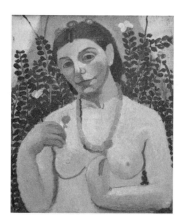

FIG. 24-09A MODERSOHN-BECKER, *Self-Portrait*, 1906.

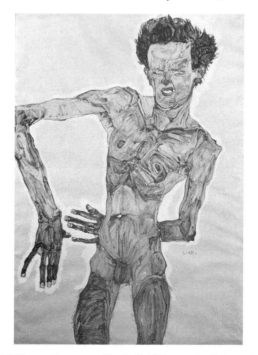

FIG. 24-10 EGON SCHIELE, *Nude Self-Portrait, Grimacing*, 1910. Gouache, watercolor, and pencil on paper, 1′ 10″ × 1′ 2 3/8″. Albertina, Vienna.

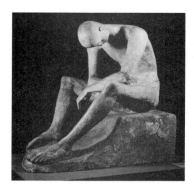

FIG. 24-10A LEHMBRUCK, *Seated Youth*, 1917.

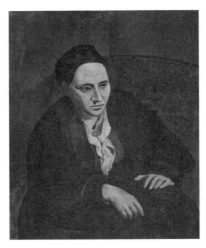

FIG. 24-11 PABLO PICASSO, *Gertrude Stein,* 1906–1907. Oil on canvas, 3′ 3 3/8″ × 2′ 8″. Metropolitan Museum of Art, New York (bequest of Gertrude Stein, 1947.)

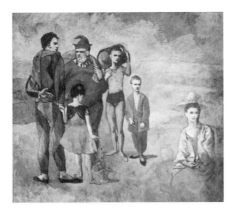

FIG. 24-11A PICASSO, *Family of Saltimbanques,* 1905.

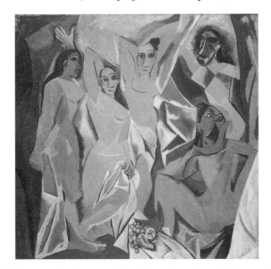

FIG. 24-12 PABLO PICASSO, *Les Demoiselles d'Avignon,* 1907. Oil on canvas, 8′ × 7′ 8″. Museum of Modern Art, New York (acquired through the Lillie P. Bliss Bequest).

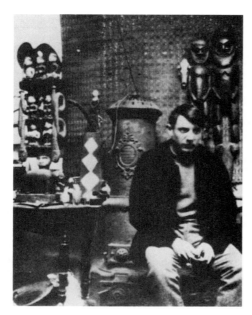

FIG. 24-13 FRANK GELETT BURGESS, Photograph of Pablo Picasso in his studio in the rue Ravignan, Paris, France, 1908. Musée Picasso, Paris.

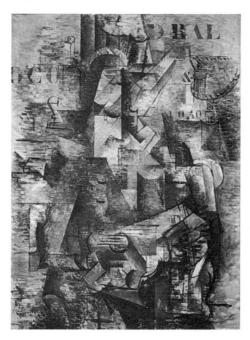

FIG. 24-14 GEORGE BRAQUE, _The Portuguese,_ 1911. Oil on canvas 3′ 10 1/8″ × 2′ 8″. Kunstmuseum, Basel (gift of Raoul La Roche, 1952).

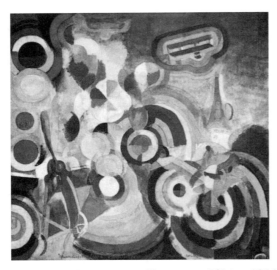

FIG. 24-15 ROBERT DELAUNAY, *Homage to Blériot*, 1914. Oil on canvas, 8′2 1′2″ × 8′3″. Kunstmuseum Basel, Basel (Emanuel Hoffman Foundation).

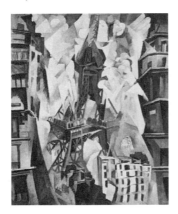

FIG. 24-15A DELAUNAY, *Champs de Mars*, 1911.

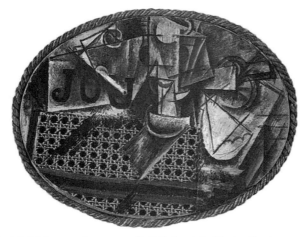

FIG. 24-16 PABLO PICASSO, *Still Life with Chair-Caning*, 1912. Oil, oilcloth, and rope on canvas, 10 5/8″ × 1′ 1 3/4″. Musée Picasso, Paris.

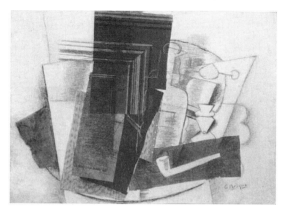

FIG. 24-17 GEORGE BRAQUE, *Bottle, Newspaper, Pipe, and Glass,* 1913. Charcoal and various papers pasted on paper, 1′ 6 7/8″ × 2′ 1 1/4″. Private collection, New York.

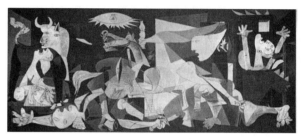

FIG. 24-18 PABLO PICASSO, *Guernica,* 1937. Oil on canvas, 11′5 1/2″ × 25′5 3/4″. Museo Nacional Centro de Arte Reina Sofia, Madrid.

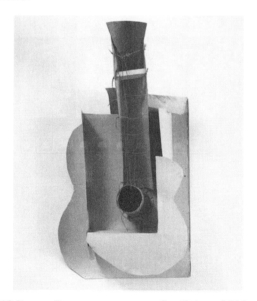

FIG. 24-19 PABLO PICASSO, maquette for *Guitar,* 1912. Cardboard, string, and wire (restored), 2′ 1 1/4″ × 1′ 1″ × 7 1/2″. Museum of Modern Art, New York.

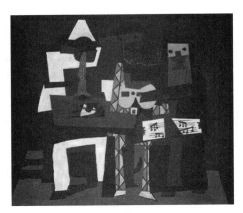

FIG. 24-19A PICASSO, *Three Musicians*, 1921.

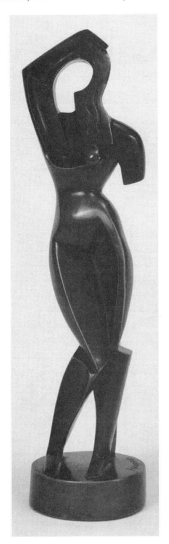

FIG. 24-20 ALEKSANDR ARCHIPENKO, *Woman Combing Her Hair,* 1915. Bronze, 1′ 1 3/4″ × 3 1/4″ × 3 1/8″. Museum of Modern Art, New York (acquired through the Lillie P. Bliss Bequest).

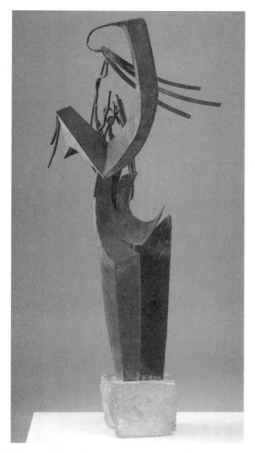

FIG. 24-21 Julio González, *Woman Combing Her Hair,* 1936. Iron, 4′ 4″ × 1 11 1/2″ × 2′ 5/8″. Museum of Modern Art, New York (Mrs. Simon Guggenheim Fund).

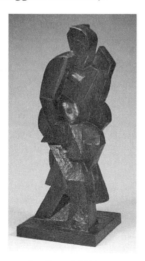

FIG. 24-21A Lipchitz, *Bather*, 1917.

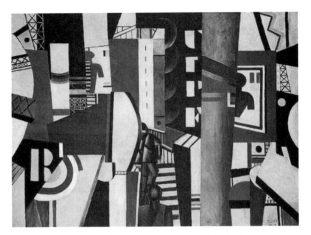

FIG. 24-22 FERNAND LÉGER, *The City,* 1919. Oil on canvas, 7′ 7″ × 9′ 9 1/2″. Philadelphia Museum of Art, Philadelphia (A. E. Gallatin Collection).

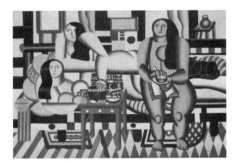

FIG. 24-22A LÉGER, *Three Women,* 1921.

FIG. 24-23 GIACOMA BALLA, *Dynamism of a Dog on a Leash,* 1912. Oil on canvas, 2′ 11 3/8″ × 3′ 7 1/4″. Albright-Knox Art Gallery, Buffalo (bequest of A. Conger Goodyear, gift of George F. Goodyear, 1964).

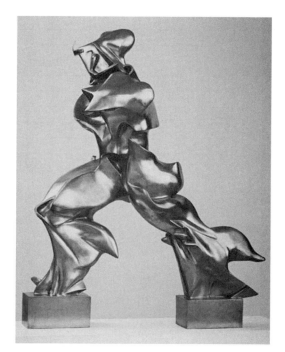

FIG. 24-24 UMBERTO BOCCIONI, *Unique Forms of Continuity in Space,* 1913 (cast 1931). Bronze, 3′ 7 7/8″ × 2′ 10 7/8″ × 1′ 3 3/4″. Museum of Modern Art, New York (acquired through the Lillie P. Bliss Bequest).

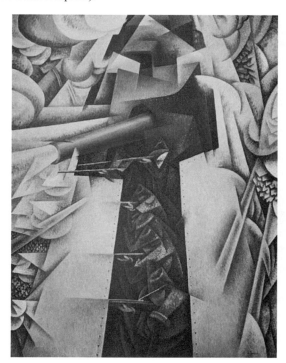

FIG. 24-25 GINO SEVERINI, *Armored Train,* 1915. Oil on canvas, 3′ 10″ × 2′ 10 1/8″. Collection of Richard S. Zeisler, New York.

FIG. 24-26 JEAN (HANS) ARP, *Collage Arranged According to the Laws of Chance,* 1916–1917. Torn and pasted paper, 1′ 7 1/8″ × 1′ 1 5/8″. Museum of Modern Art, New York.

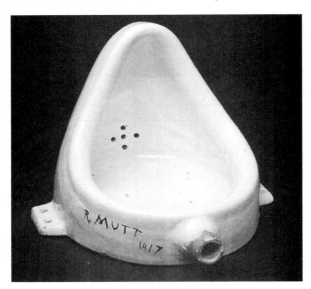

FIG. 24-27 MARCEL DUCHAMP, *Fountain* (second version), 1950 (original version produced 1917). Glazed sanitary china with black paint, 1′ high. Philadelphia Museum of Art, Philadelphia.

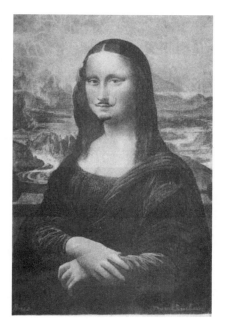

FIG. 24-27A DUCHAMP, *L.H.O.O.Q.*, 1919.

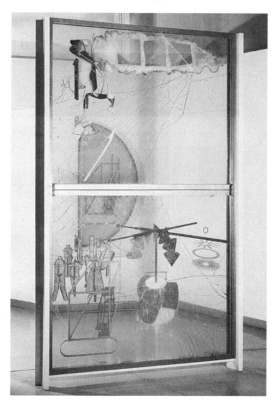

FIG. 24-28 MARCEL DUCHAMP, *The Bride Stripped Bare by Her Bachelors, Even (The Large Glass)*, 1915–1923. Oil, lead, wire, foil, dust, and varnish on glass, 9′ 1 1/2″ × 5′ 9 1/8″. Philadelphia Museum of Art, Philadelphia (Katherine S. Dreier Bequest).

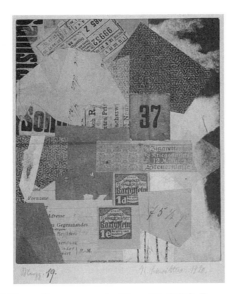

FIG. 24-29 KURT SCHWITTERS, *Merz 19,* 1920. Paper collage, 7 1/4″ × 5 7/8″. Yale University Art Gallery, New Haven (gift of Collection Société Anonyme).

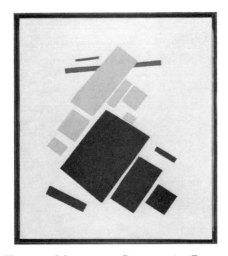

FIG. 24-30 KAZIMIR MALEVICH, *Supermatist Composition: Airplane Flying*, 1915 (dated 1914). Oil on canvas, 1′10 7/8″ × 1′7″. Museum of Modern Art, New York.

FIG. 24-30A POPOVA, *Architectonic Painting*, 1916–1917.

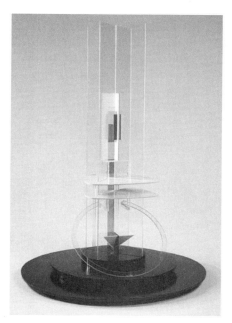

FIG. 24-31 NAUM GABO, *Column*, ca. 1923 (reconstructed 1937). Perspex, wood, metal, glass, 3′ 5″ × 2′ 5″ × 2′ 5″. Solomon R. Guggenheim Museum, New York.

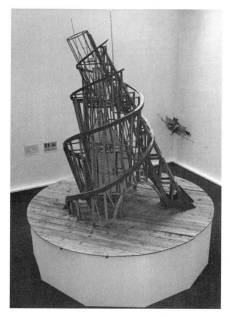

FIG. 24-32 VLADIMIR TATLIN, *Monument of the Third International*, 1919–1920. Reconstruction of the lost model, 1992–1993. Kunsthalle, Düsseldorf.

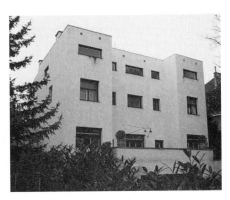

FIG. 24-33 ADOLF LOOS, garden facade of the Steiner House (looking northwest), Vienna, Austria, 1910.

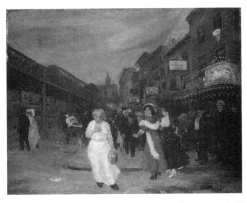

FIG. 24-34 JOHN SLOAN, *Sixth Avenue and Thirtieth Street, New York City*, 1907. Oil on canvas, 2′1/4″ × 2′8″. Philadelphia Museum of Art, Philadelphia (gift of Meyer P. Potamkin and Vivian O. Potamkin, 2000).

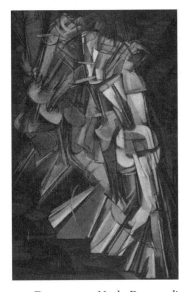

FIG. 24-35 MARCEL DUCHAMP, *Nude Descending a Staircase, No. 2*, 1912. Oil on canvas, 4′10″ × 2′11″. Philadelphia Museum of Art, Philadelphia (Louise and Walter Arensberg Collection).

206

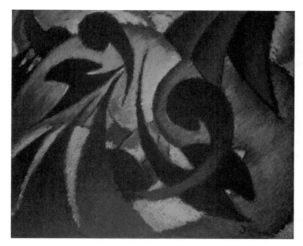

FIG. 24-36 ARTHUR DOVE, *Nature Symbolized No. 2*, ca. 1911. Pastel on paper, 1′6″ × 1′9 5/8″. Art Institute of Chicago, Chicago (Alfred Stieglitz Collection).

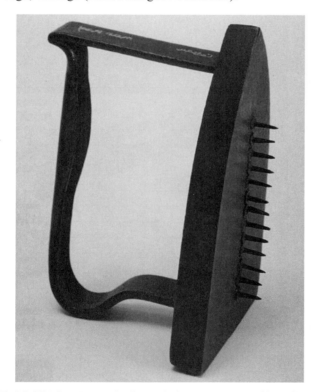

FIG. 24-37 MAN RAY, *Cadeau (Gift)*, ca. 1958 (replica of 1921 original). Painted flatiron with row of 13 tracks with heads glued to the bottom, 6 1/8″ × 3 5/8″ × 4 1/2″. Museum of Modern Art, New York (James Thrall Soby Fund).

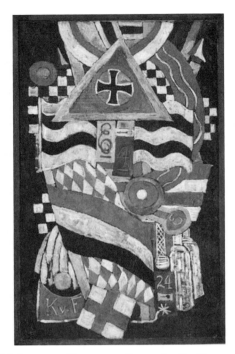

FIG. 24-38 MARSDEN HARTLEY, *Portrait of a German Officer*, 1914. Oil on canvas, 5′ 8 1/4″ × 3′5 3/8″. Metropolitan Museum of Art, New York (Alfred Stieglitz Collection).

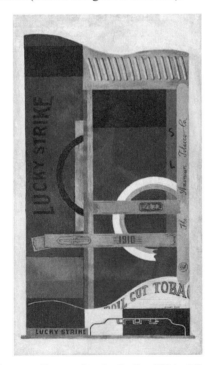

FIG. 24-39 STUART DAVIS, *Lucky Strike*, 1921. Oil on canvas, 2′9 1/4″ × 1′6″. Museum of Modern Art, New York (gift of the American tobacco Company, Inc.). © Estate of Stuart Davis/Licensed by VAGA, New York.

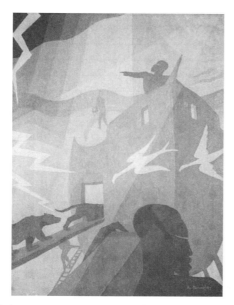

FIG. 24-40 AARON DOUGLAS, *Noah's Ark*, ca. 1927. Oil on Masonite, 4′ × 3′. Fisk University Galleries, University of Tennesse, Nashville.

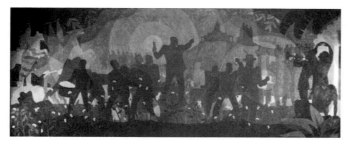

FIG. 24-40A DOUGLAS, *Slavery through Reconstruction*, 1934.

FIG. 24-41 CHARLES DEMUTH, *My Egypt*, 1927. Oil on composition board, 2′11 3/4″ × 2′6″. Whitney Museum of American Art, New York (purchased with funds from Gertrude Vanderbilt Whitney).

FIG. 24-42 GEORGIA O'KEEFFE, *New York, Night*, 1929. Oil on canvas, 3'4 1/8 × 1'7 1/8". Sheldon Memorial Art Gallery, Lincoln (Nebraska Art Association, Thomas C. Woods Memorial collection).

FIG. 24-43 ALFRED STIEGLITZ, *The Steerage*, 1907 (print 1915). Photogravure (on tissue). 1' 3/8" × 10 1/8". Amon Carter Museum, Fort Worth.

FIG. 24-43A STIEGLITZ, *Equivalent*, 1923.

FIG. 24-44 EDWARD WESTON, *Pepper No. 30*, 1930. Gelatin silver print, 9 1/2″ × 7 1/2″. Center for Creative Photography, University of Arizona, Tucson.

FIG. 24-44A WESTON, *Nude*, 1925.

FIG. 24-45 FRANK LLOYD WRIGHT, Robie House (looking northeast), Chicago, Illinois, 1907–1909.

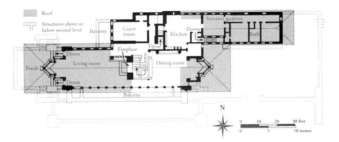

FIG. 24-46 FRANK LLOYD WRIGHT, plan of the second (main) level of the Robie House, Chicago, Illinois, 1907–1909.

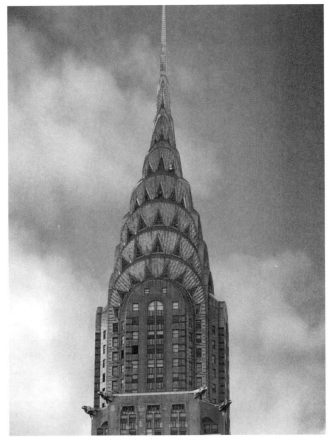

FIG. 24-47 WILLIAM VAN ALEN, Art Deco spire of the Chrysler Building (looking south), New York, New York, 1928–1930.

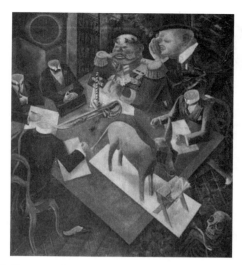

FIG. 24-48 GEORGE GROSZ, *The Eclipse of the Sun*, 1926. Oil on canvas, 6′9 5/8″ × 5′11 7/8″. Heckscher Museum of Art, Huntington.

FIG. 24-48A GROSZ, *Fit for Active Service*, 1916–1917.

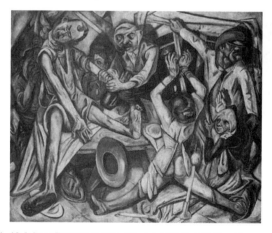

FIG. 24-49 MAX BECKMANN, *Night*, 1918–1919. oil on canvas, 4′4 3/8″ × 5′ 1/4″. Kunstsammlung Norhrhein-Westfalen, Düsseldorf.

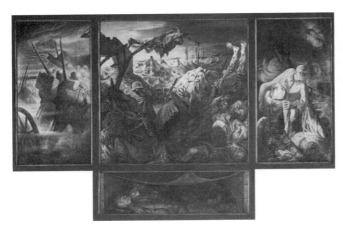

FIG. 24-50 OTTO DIX, *Der Krieg (the War)*, 1929–1932. Oil and tempera on wood, 6′ 8 1/3″ × 13′ 4 3/4″. Staartliche Kunstammlungen, Gemäldegalerie Neue Meister, Dresden.

FIG. 24-51 ERNST BARLACH, *War Mounument*, Güstrow Cathedral, Güstrow, Germany, 1927. Bronze.

FIG. 24-52 GIORGIO DE CHIRICO, *The Song of Love*, 1914. Oil on canvas, 2′4 3/4″ × 1′11 3/8″. Museum of Modern Art, New York (Nelson A. Rockefeller bequest).

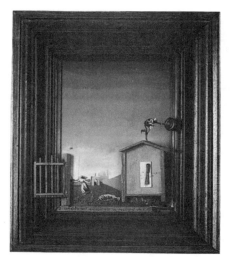

FIG. 24-53 MAX ERNST, *Two Children Are Threatened by a Nightingale*, 1924. Oil on wood with wood construction, 2′3 1/2″ × 1′10 1/2″ × 4 1/2″. Museum of Modern Art, New York.

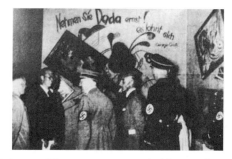

FIG. 24-54 ADOLF HITLER, accompanied by Nazi commission members, including photographer Heinrich Hoffmann, Wolfgang Willrich, Walter Hansen, and painter Adolf Ziegler, viewing the "Entartete Kunst" show on July 16, 1937.

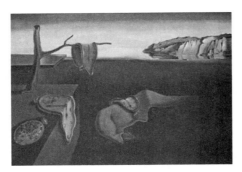

FIG. 24-55 SALVADOR DALÍ, *The Persistence of Memory*, 1931. Oil on canvas, 9 1/2″ × 1′ 1″. Museum of Modern Art, New York.

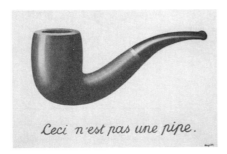

FIG. 24-56 RENÉ MAGRITTE, *The Treachery (or Perfidy) of Images*, 1928–1929. Oil on canvas, 1′11 5/8″ × 3′1″. Los Angeles County Museum of Art, Los Angeles (purchased with funds provided by the Mr. and Mrs. William Preston Harrison Collection).

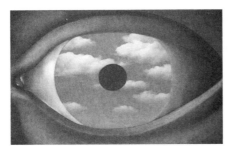

FIG. 24-56A MAGRITTE, *The False Mirror*, 1928.

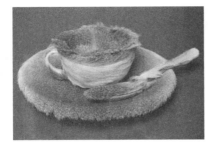

FIG. 24-57 MERET OPPENHEIM, *Object (Le Déjeuner en fourrure)*, 1936. Fur-covered cup, 4 3/8″ diameter; saucer, 9 3/8″ diameter; spoon, 8″ long. Museum of Modern Art, New York.

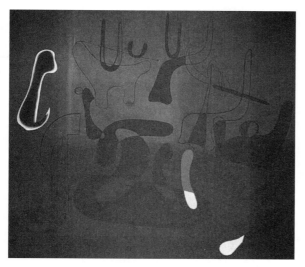

FIG. 24-58 JOAN MIRÓ, *Painting*, 1933. Oil on canvas, 5′8″ × 6′5″. Museum of Modern Art, New York (Loula D. Lasker bequest by exchange).

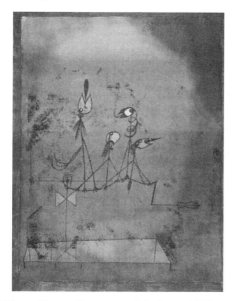

FIG. 24-59 PAUL KLEE, *Twittering Machine*, 1922. Watercolor and pen and ink, on oil transfer drawing on paper, mounted on cardboard, 2′1″ × 1′7″. Museum of Modern Art, New York.

FIG. 24-59A LAM, *The Jungle*, 1943.

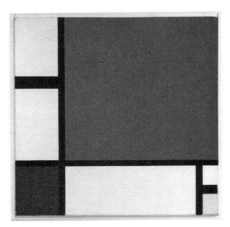

FIG. 24-60 PIET MONDRIAN, *Composition with Red, Blue, and Yellow*, 1930. Oil on canvas, 1′ 6 1/8″ × 1′ 6 1/8″. Kunsthaus, Zürich. © Mondrian/Holtzman Trust c/o HCR International, VA, USA.

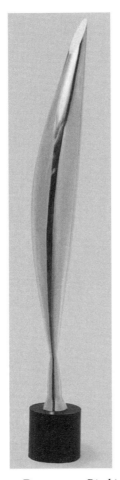

FIG. 24-61 CONSTANTIN BRANCUSI, *Bird in Space*, 1924. Bronze, 4′2 5/16″ high. Philadelphia Museum of Art, Philadelphia (Louise and Walter Arensberg Collection, 1950).

FIG. 24-61A BRANCUSI, *The Newborn*, 1915.

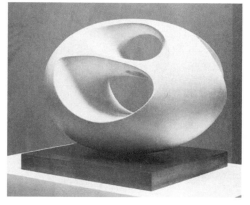

FIG. 24-62 BARBARA HEPWORTH, *Oval Sculpture (No. 2)*, 1943, cast 1958, plaster, 11 1/4″ × 1′4 1/4″ × 10″. Tate.

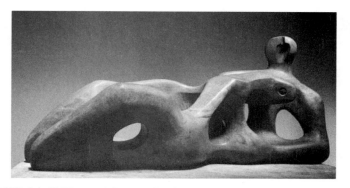

FIG. 24-63 HENRY MOORE, *Reclining Figure*, 1939, Elm wood, 3′1″ × 6′7″ × 2′6″. Detroit Institute of Arts, Detroit (Founders Society purchase with funds from the Dexter M. Ferry Jr. Trustee Corporation).

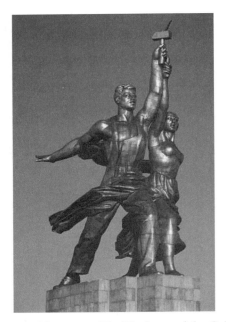

FIG. 24-64 VERA MUKHINA, *The Worker and the Collective Farm Worker*, Soviet Pavillion, Paris Exposition, 1937. Stainless stell, 78′ high. © Estate of Vera Mukhina/ROA, Moscow/VAGA, New York.

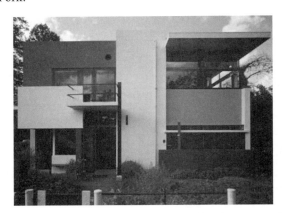

FIG. 24-65 GERRIT THOMAS RIETVELD, Schröder House (looking northwest), Utrecht, the Netherlands, 1924.

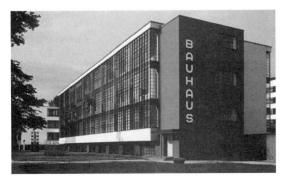

FIG. 24-66 WALTER GROPIUS, Shop Block (looking northeast), the Bauhaus, Dessau, Germany, 1925–1926.

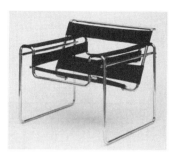

FIG. 24-66A BREUER, Wassily chair, 1925.

FIG. 24-66B STÖLZL, Gobelin tapestry, 1927–1928.

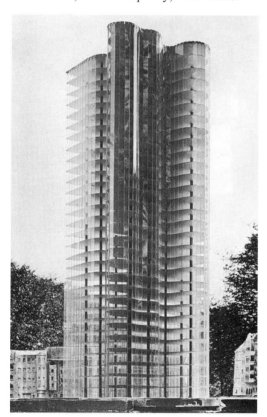

FIG. 24-67 LUDWIG MIES VAN DER ROHE, model for a glass skyscraper, Berlin, Germany, 1922 (no longer extant).

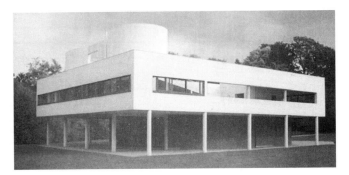

FIG. 24-68 LE CORBUSIER, Villa Savoye (looking southeast), Poissy-sur-Seine, France, 1929.

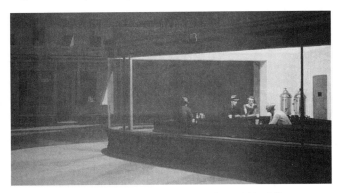

FIG. 24-69 EDWARD HOPPER, *Nighthawks*, 1942. Oil on canvas, 2′6″ × 4′8 11/16″. Art Institute of Chicago, Chicago (Friends of American Art Collection).

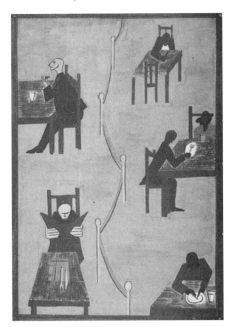

FIG. 24-70 JACOB LAWRENCE, *No. 49 from The Migration of the Negro*, 1940–1941. Tempera on Masonite, 1′6″ × 1′. Phillips Collection, Washington, D.C.

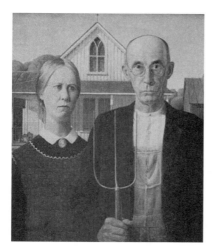

FIG. 24-71 GRANT WOOD, *American Gothic*, 1930. Oil on beaverboard, 2′5 7/8″ × 2′7/8″. Art Institute of Chicago, Chicago (Friends of American Art Collection).

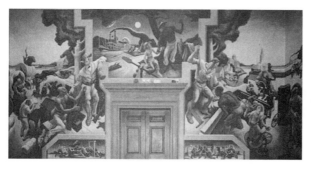

FIG. 24-72 THOMAS HART BENTON, *Pioneer Days and Early Settlers*, fresco in the State Capitol, Jefferson City, Missouri, 1936. © T. H. Benton and R. P. Benton Testamentary Trusts/UMB Bank Trustee/Licensed by VAGA, New York.

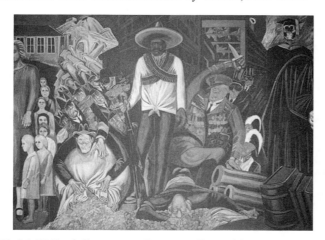

FIG. 24-73 JOSÉ CLEMENTE OROZCO, *Epic of American Civilization: Hispano-America* (panel 16), fresco in Baker Memorial Library, Dartmouth College, Hanover, New Hampshire, ca. 1932–1934.

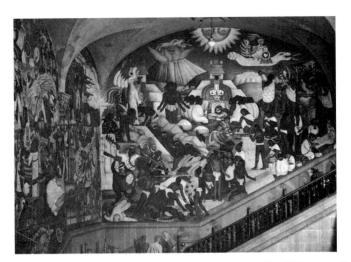

FIG. 24-74 DIEGO RIVERA, *Ancient Mexico*, detail of *History of Mexico*, fresco in the Placio Nacional, Mexico City, 1929–1935.

FIG. 24-74A TAMAYO, *Friends of the Birds*, 1944.

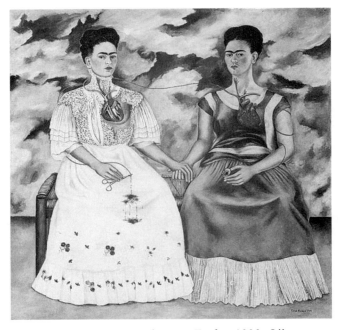

FIG. 24-75 FRIDA KAHLO, *The Two Fridas*, 1939. Oil on canvas, 5′7″ × 5′7″. Museo de Arte Moderno, Mexico City.

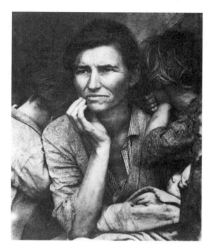

FIG. 24-76 Dorothea Lange, *Migrant Mother, Nipomo Valley,* 1935. Gelatin silver print, 1′1″ × 9″. Oakland Museum of California, Oakland (gift of Paul S. Taylor.)

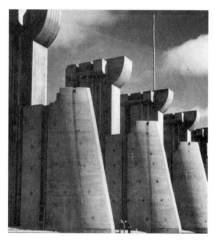

FIG. 24-77 Margaret Bourke-White. *Fort Peck Dam, Montana,* 1936. Gelatin silver print, 1′ 1″ × 10 1/2″. Metropolitan Museum of Art, New York (gift of Ford Motor Company and John C. Waddell, 1987).

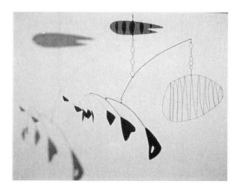

FIG. 24-78 Alexander Calder, *Lobster Trap and Fish Tail,* 1939. Painted sheet aluminum and steel wire, 8′6″ × 9′6″. Museum of Modern Art, New York.

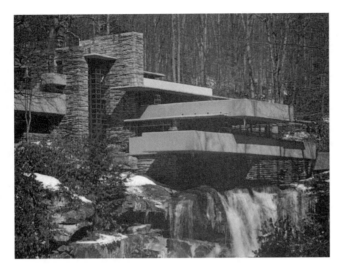

FIG. 24-79 FRANK LLOYD WRIGHT, Kaufmann House (Fallingwater; looking northeast), Bear Run, Pennsylvania, 1936–1939.

Chapter 25

Modernism and Postmodernism in Europe and America, 1945 to 1980

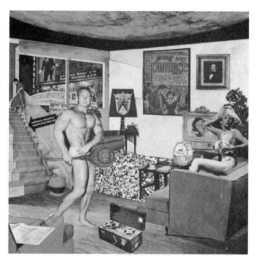

FIG. 25-01 RICHARD HAMILTON, *Just What Is It That Makes Today's Home So Different, So Appealing?* 1956. Collage, 10 1/4″ × 9 3/4″. Kunsthalle Tübingen, Tübingen.

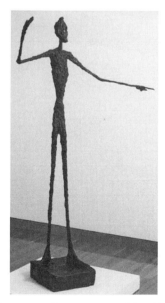

FIG. 25-02 ALBERTO GIACOMETTI, *Man Pointing No. 5, 1947.* Bronze, 5′ 10″ high. Des Moines Art Center, Des Moines (Nathan Emory Coffin Collection).

227

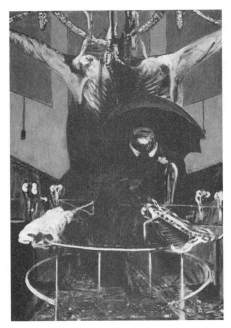

FIG. 25-03 Francis Bacon, *Painting,* 1946. Oil and pastel on linen, 6′ 5 7/8″ × 4′ 4″. Museum of Modern Art, New York.

FIG. 25-03A Bacon, *Figure with Meat*, 1954.

FIG. 25-04 Jean Dubuffet, *Vie Inquiète*, 1953. Oil on canvas, 4′ 3″ × 6′ 4″. Tate Modern, London (gift of the artist, 1966).

FIG. 25-05 ARSHILE GORKY, *Garden in Sochi,* ca. 1943. Oil on canvas, 2′ 7″ × 3′ 3″. Museum of Modern Art, New York (acquired through the Lillie P. Bliss Bequest).

FIG. 25-06 JACKSON POLLOCK, *Number 1, 1950 (Lavender Mist),* 1950. Oil, enamel, and aluminum paint on canvas, 7′ 3″ × 9′ 10″. National Gallery of Art, Washington, D.C. (Ailsa Mellon Bruce Fund).

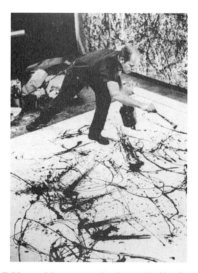

FIG. 25-07 HANS NAMUTH, Jackson Pollock painting in his studio in Springs, Long Island, New York, 1950. Gelatin silver print, 10″ × 8″. Center for Creative Photography, University of Arizona, Tucson.

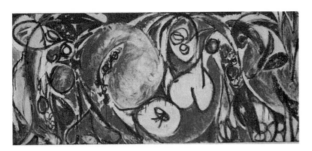

FIG. 25-07A KRASNER, *The Seasons*, 1957.

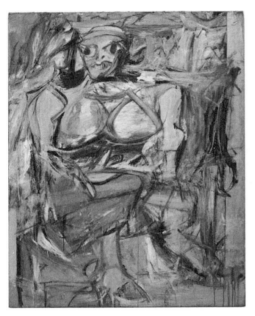

FIG. 25-08 WILLEM DE KOONING, *Woman I,*
1950–1952. Oil on canvas, 6′ 3 7/8″ × 4′ 10″.
Museum of Modern Art, New York.

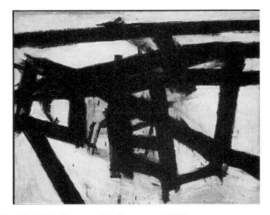

FIG. 25-08A KLINE, *Mahoning*, 1956.

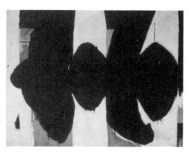

FIG. 25-08B MOTHERWELL, *Elegy to the Spanish Republic*, 1953–1954.

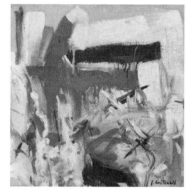

FIG. 25-08C MITCHELL, *Untitled*, ca. 1953–1954.

FIG. 25-08D ROTHENBERG, *Tattoo*, 1979.

FIG. 25-09 BARNETT NEWMAN, *Vir Heroicus Sublimis,* 1950–1951. Oil on canvas, 7′ 11 3/8″ × 17′ 9 1/4″. Museum of Modern Art, New York (gift of Mr. and Mrs. Ben Heller).

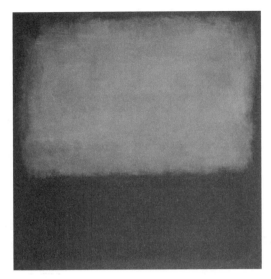

FIG. 25-10 MARK ROTHKO, *No. 14,* 1960. Oil on canvas, 9′ 6″ × 8′ 9″. San Francisco Museum of Modern Art, San Francisco (Helen Crocker Russell Fund Purchase).

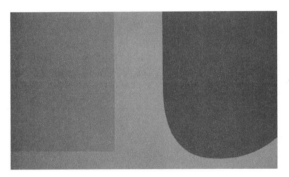

FIG. 25-11 ELLSWORTH KELLY, *Red Blue Green,* 1963. Oil on canvas, 6′ 11 5/8″ × 11′ 3 7/8″. Museum of Contemporary Art, San Diego (gift of Dr. and Mrs. Jack M. Farris).

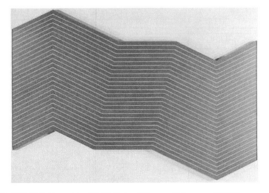

FIG. 25-12 FRANK STELLA, *Mas o Menos*, 1964. Metallic powder in acrylic emulsion on canvas, 9′ 10″ × 13′ 8 1/2″. Musée National d'Art Moderne, Centre Georges Pompidou, Paris (purchase 1983 with participation of Scaler Foundation).

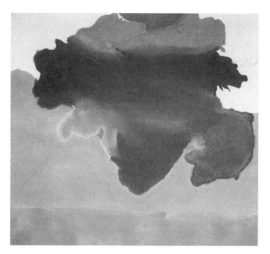

FIG. 25-13 Helen Frankenthaler, *The Bay,* 1963. Acrylic on canvas, 6′ 8 7/8″ × 6′ 9 7/8″. Detroit Institute of Arts, Detroit.

FIG. 25-14 Morris Louis, *Saraband,* 1959. Acrylic resin on canvas, 8′ 5 1/8″ × 12′ 5″. Solomon R. Guggenheim Foundation, New York.

FIG. 25-15 Bridget Riley, *Fission,* 1963. Tempera on composition board 2′ 11″ × 2′ 10″. Museum of Modern Art, New York (gift of Philip Johnson).

233

FIG. 25-16 DAVID SMITH, *Cubi XII*, 1963, Stainless steel, 9′1 5/8″ high. Hirshhorn Museum and Sculpture Garden, Smithsonian Institution, Washington, D.C. (gift of the Joseph H. Hirshhorn Foundation, 1972). Art © David Smith, Licensed by VAGA, NY. Photo by Lee Stalsworth, Smithsonian Hirshhorn Museum and Sculpture Garden.

FIG. 25-17 TONY SMITH, *Die,* 1962. Steel, 6′ × 6′ × 6′. Museum of Modern Art, New York (gift of Jane Smith in honor of Agnes Gund).

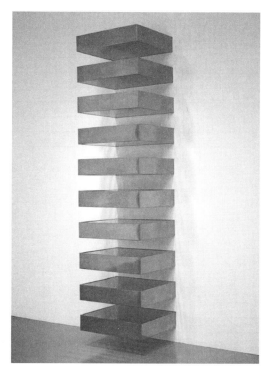

FIG. 25-18 DONALD JUDD, *Untitled,* 1969. Brass and colored fluorescent Plexiglass on steel brackets, 10 units, 6 1/8″ × 2′ × 2′ 3″ each, with 6″ intervals. Hirshhorn Museum and Sculpture Garden, Smithsonian Institution, Washington, D.C. (gift of Joseph H. Hirshhorn, 1972). © Donald Judd Estate/Licensed by VAGA, New York.

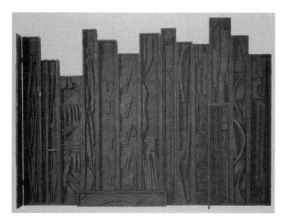

FIG. 25-19 LOUISE NEVELSON, *Tropical Garden II,* 1957–1959. Wood painted black, 5′ 11 1/2″ × 10′ 11 3/4″ × 1′. Musée National d'Art Moderne, Centre Georges Pompidou, Paris.

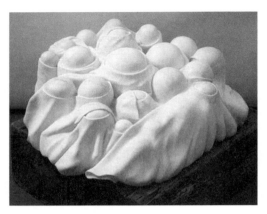

FIG. 25-20 LOUISE BOURGEOIS, *Cumul I,* 1969. Marble, 1′ 10 3/8″ × 4′ 2″ × 4′. Musée National d'Art Moderne, Centre Georges Pompidou, Paris. © Louise Bourgeois/Licensed by VAGA, New York.

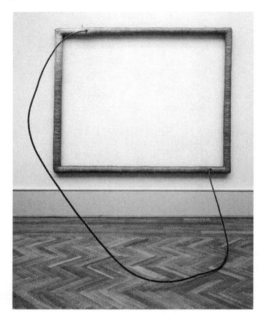

FIG. 25-21 EVA HESSE, *Hang-Up,* 1965–1966. Acrylic on cloth over wood and steel, 6′ × 7′ × 6′ 6″. Art Institue of Chicago, Chicago (gift of Arthur Keating and Mr. and Mrs. Edward Morris by exchange).

FIG. 25-21A NOGUCHI, *Shodo Shima,* 1978.

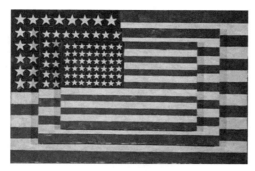

FIG. 25-22 JASPER JOHNS, *Three Flags,* 1958. Encaustic on canvas, 2′ 6 7/8″ × 3′ 9 1/2″. Whitney Museum of American Art, New York (50th Anniversary Gift of the Gilman Foundation, the Lauder Foundation, and A. Alfred Taubman).

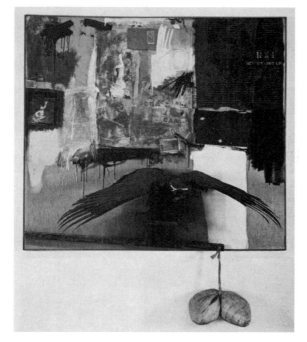

FIG. 25-23 ROBERT RAUSCHENBERG, *Canyon,* 1959. Oil, pencil, paper, fabric, metal, cardboard box, printed paper, printed reproductions, photograph, wood, paint tube, and mirror on canvas, with oil on bald eagle, string, and pillow, 6′ 9 3/4″ × 5′ 10″ × 2′. Sonnabend Collection, New York. © Robert Rauchenberg/ Licensed by VAGA, New York.

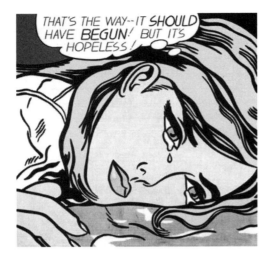

FIG. 25-24 ROY LICHTENSTEIN, *Hopeless,* 1963. Oil and synthetic polymer paint on canvas, 3′ 8″ × 3′ 8″. Kunstmuseum Basel, Basel. © Estate of Roy Lichtenstein.

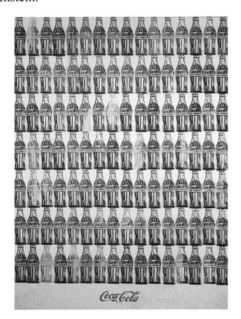

FIG. 25-25 ANDY WARHOL, *Green Coca-Cola Bottles,* 1962. Oil on canvas, 6′ 10 1/2″ × 4′ 9″. Whitney Museum of American Art, New York.

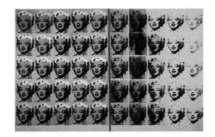

FIG. 25-25A WARHOL, *Marlyn Diptych,* 1962.

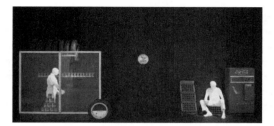

FIG. 25-25B SEGAL, *Gas Station*, 1963.

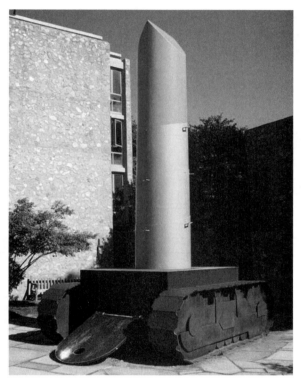

FIG. 25-26 CLAES OLDENBURG, *Lipstick (Ascending) on Caterpillar Tracks*, 1969; reworked, 1974. Painted steel, aluminum, and fiberglass, 21′ high. Morse College, Yale University, New Haven (gift of Colossal Keepsake Corporation).

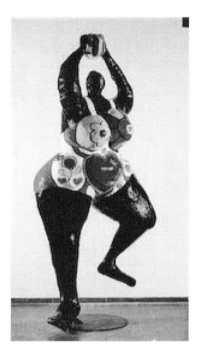

FIG. 25-26A SAINT-PHALLE, *Black Venus*, 1965–1967.

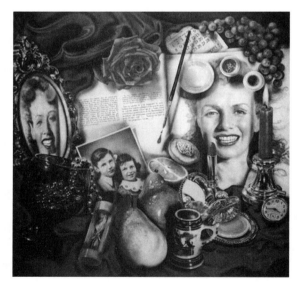

FIG. 25-27 AUDRY FLACK, *Marilyn,* 1977. Oil over acrylic on canvas, 8′ × 8′. University of Arizona Museum, Tuscon (museum purchase with funds provided by the Edward J. Gallagher Jr. Memorial Fund).

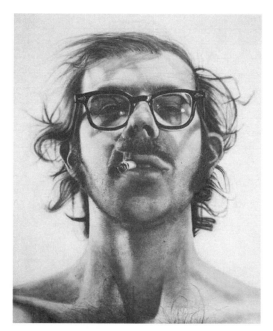

FIG. 25-28 CHUCK CLOSE, *Big Self-Portrait,*
1967–1968. Acrylic on canvas, 8′ 11″ × 6′ 11″.
Walker Art Center, Minneapolis (Art Center Acquisition
Fund, 1969).

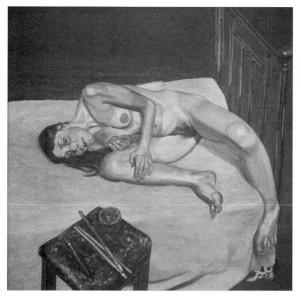

FIG. 25-29 LUCIAN FREUD, *Naked Portrait*, 1972–1973.
Oil on canvas, 2′ × 2′. Tate Modern, London.

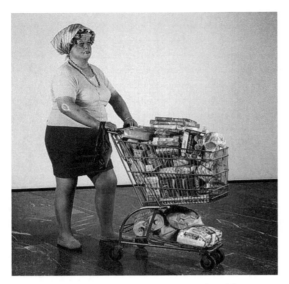

FIG. 25-30 DUANE HANSON, *Supermarket Shopper,* 1970. Polyester resin and fiberglass polychromed in oil, with clothing, steel cart, and groceries, life-size. Nachfolgeinstitut, Neue Galerie, Sammlung Ludwig, Aachen. © Estate of Duane Hanson/Licensed by VAGA, New York.

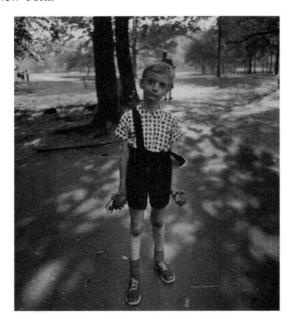

FIG. 25-31 DIANE ARBUS, *Child with Toy Hand Grenade*, New York, New York, 1962. Gelatin silver print, 7 1/4″ × 8 3/8″. The Museum of Modern Art, New York.

FIG. 25-32 MINOR WHITE, *Moencopi Strata, Capitol Reef, Utah*, 1962. Gelatin silver spint, 1′1/8″ × 9 1/4″. Museum of Modern Art, New York. The Minor White Archive, Princeton University.

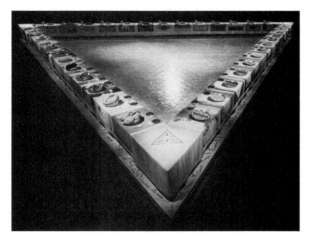

FIG. 25-33 JUDY CHICAGO, *The Dinner Party,* 1979. Multimedia, including ceramics and stitchery, 48′ long on each side. The Brooklyn Museum, Brooklyn.

FIG. 25-34 MIRIAM SCHAPIRO, *Anatomy of a Kimono* (detail of a 10-panel composition), 1976. Fabric and acrylic on canvas, entire work 6′ 8″ × 52′ 2 1/2″. Collection of Bruno Bishofberger, Zurich.

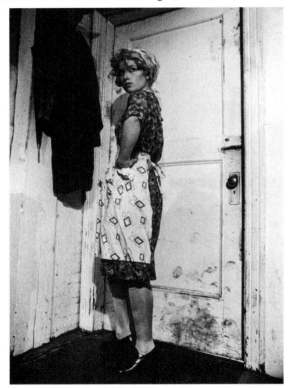

FIG. 25-35 CINDY SHERMAN, *Untitled Film Still #35,* 1979. Gelatin silverprint, 10″ × 8″. Private collection.

FIG. 25-36 ANA MENDIETA, *Flowers on Body,* 1973. Color photograph of earth/body work with flowers, executed at El Yagul, Mexico. Courtesy of the Estate of Ana Mendieta and Galerie Lelong, New York.

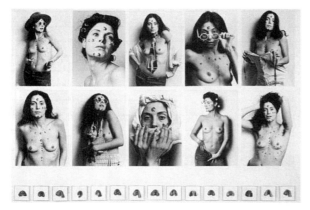

FIG. 25-37 HANNAH WILKE, *S.O.S. Stratification Objects Series,* 1974–1982. 10 black and white photographs and 16 chewing gum sculptures mounted on ragboard, 3′5″ × 4′10″ framed. © Marsie, Emanuelle, Damon, and Andrew Scharlatt/Licensed by VAGA, New York, NY. Courtesy Ronald Feldman Fine Arts, New York.

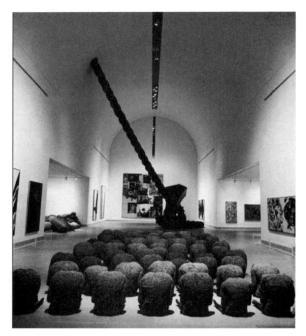

FIG. 25-38 MAGDALENA ABAKANOWICZ, *80 Backs,* 1976–1980. Burlap and resin, each figure 2′ 3″ high. Museum of Modern Art, Dallas.

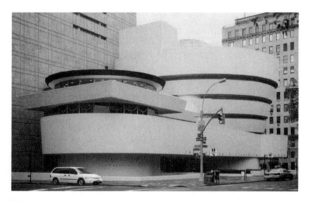

FIG. 25-39 FRANK LLOYD WRIGHT, Solomon R. Guggenheim Museum (looking southeast), New York, 1943–1959.

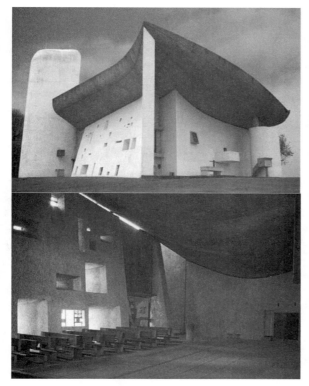

FIG. 25-40 LE CORBUSIER, Notre-Dame-du-Haut, Ronchamp, France, 1950–1955. *Top*: exterior looking northwest; *bottom*: interior looking southwest.

FIG. 25-41 EERO SAARINEN, Terminal 5 (Jet Blue Airways terminal, formerly the Trans World Airlines terminal; looking southeast), John F. Kennedy Internation Airport, New York, 1956–1962.

FIG. 25-42 JOERN UTZON, Sydney Opera House (looking southeast), Sydney, Australia, 1959–1972.

FIG. 25-43 LUDWIG MIES VAN DER ROHE and PHILIP JOHNSON, Seagram Building (looking northeast), New York, 1956–1958.

FIG. 25-44 SKIDMORE, OWINGS and MERRILL, Willis Tower (formerly Sears Tower; looking east), Chicago, 1974.

FIG. 25-45 CHARLES MOORE, Piazza d'Italia (looking northeast), New Orleans, 1976–1980.

FIG. 25-46 PHILIP JOHNSON and JOHN BURGEE (with *Simmons Architects*), Sony Building (formerly AT&T Building; looking southwest), New York, 1978–1984.

FIG. 25-47 MICHAEL GRAVES, Portland Building (looking northwest), Portland, 1980.

FIG. 25-48 ROBERT VENTURI, Vanna Venturi House, Chestnut Hill, Pennsylvania, 1962.

FIG. 25-49 RICHARD ROGERS and RENZO PIANO, Centre Georges Pompidou (the "Beaubourg," looking northeast), Paris, France, 1977.

FIG. 25-50 ROBERT SMITHSON, *Spiral Jetty* (looking northeast), Great Salt Lake, Utah, 1970. © Estate of Robert Smithson/Licensed by VAGA, New York.

FIG. 25-51 CAROLEE SCHNEEMANN, *Meat Joy* (performance at Judson Church, New York City), *1964.*

FIG. 25-52 JOSEPH BEUYS, *How to Explain Pictures to a Dead Hare* (performance at Schmela Gallery, Düsseldorf), *1965.*

FIG. 25-53 JEAN TINGUELY, *Homage to New York,* 1960, just prior to its self-destruction in the garden of the Museum of Modern Art, New York.

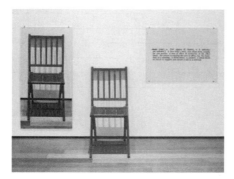

FIG. 25-54 JOSEPH KOSUTH, *One and Three Chairs,* 1965. Wooden folding chair, photographic copy of a chair, and photographic enlargement of a dictionary definition of a chair; chair, 2′ 8 3/8″ × 1′ 2 7/8″ × 1′ 8 7/8″; photo panel, 3′ × 2′ 1/8″; text panel, 2′ × 2′ 1/8″. Museum of Modern Art, New York (Larry Aldrich Foundation Fund).

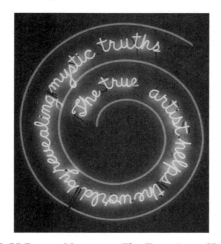

FIG. 25-55 BRUCE NAUMAN, *The True Artist Helps the World by Revealing Mystic Truths,* 1967. Neon with glass tubing suspension frame, 4′ 11″ high. Private collection.

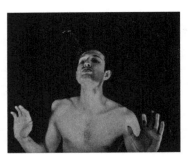

FIG. 25-55A NAUMAN, *Self-Portrait as a Fountain*, 1966–1967.

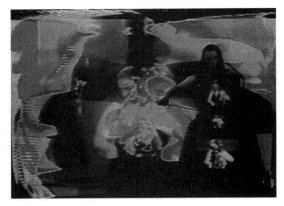

FIG. 25-56 NAM JUNE PAIK, Video still from *Global Groove,* 1973. 3/4″ video-tape, color, sound, 30 minutes. Collection of the artist.

FIG. 25-57 DAVID EM, *Nora,* 1979. Computer-generated color photograph, 1′ 5″ × 1′ 11″. Private collection.

Chapter 26

Contemporary Art Worldwide

FIG. 26-01 JAUNE QUICK-TO-SEE-SMITH, *Trade (Gifts for Trading Land with White People)*, 1992. Oil and mixed media on canvas, 5′ × 14′ 2″. Chrysler Museum of Art, Norfolk.

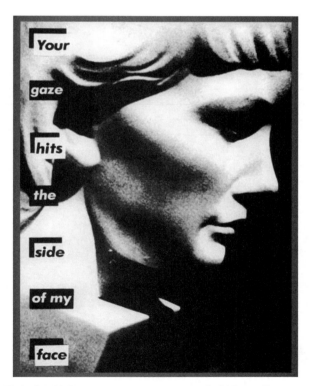

FIG. 26-02 BARBARA KRUGER, *Untitled (Your Gaze Hits the Side of My Face)*, 1981. Photograph, red painted frame, 4′ 7″ × 3′ 5″. Courtesy Mary Boone Gallery, New York.

FIG. 26-02A GUERRILLA GIRLS, *Advantages of Being a Woman Artist,* 1988.

FIG. 26-03 DAVID WOJNAROWICZ, *When I Put My Hands on Your Body,* 1990. Gelatin silver print and silk-screened text on museum board, 2′ 2″ × 3′ 2″. Private collection.

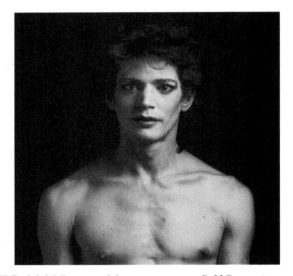

FIG. 26-04 ROBERT MAPPLETHORPE, *Self-Portrait,* 1980. Gelatin silver print, 7 ¾″ × 7 ¾″. Robert Mapplethorpe Foundation, New York.

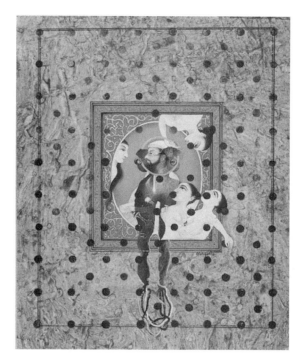

FIG. 26-05 SHAHZIA SIKANDER, *Perilous Order,*
1994–1997. Vegetable color, dry pigment, watercolor,
and tea on Wasli paper, 10 ½″ × 8″. Whitney Museum of
American Art, New York (purchase, with funds from the
Drawing Committee).

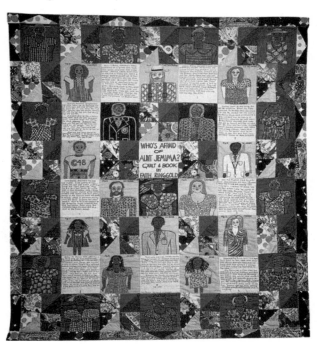

FIG. 26-06 FAITH RINGGOLD, *Who's Afraid of Aunt
Jemima?* 1983. Acrylic on canvas with fabric border,
quilted, 7′ 6″ × 6′ 8″. Private collection.

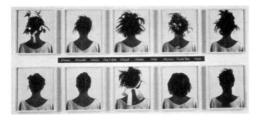

FIG. 26-06A SIMPSON, *Stereo Styles,* 1988.

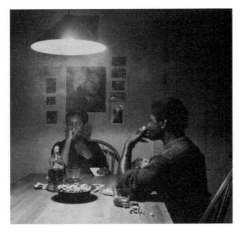

FIG. 26-06B WEEMS, *Man Smoking/Malcolm X,* 1990.

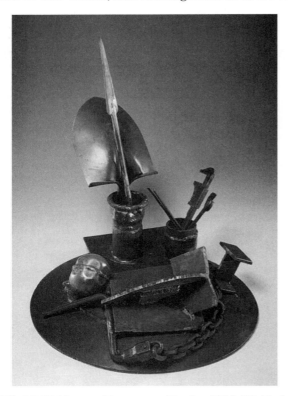

FIG. 26-07 MELVIN EDWARDS, *Tambo,* 1993. Welded steel, 2′ 4 1/8″ × 2′ 1 1/4″. Smithsonian American Art Museum, Washington, D.C.

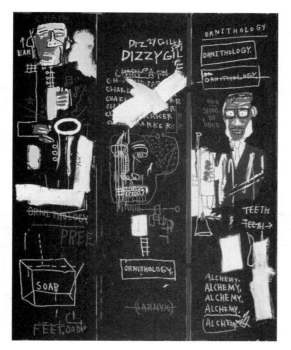

FIG. 26-08 JEAN-MICHEL BASQUIAT, *Horn Players,* 1983. Acrylic and oil paintstick on three canvas panels, 8′ × 6′3″. Broad Foundation, Santa Monica.

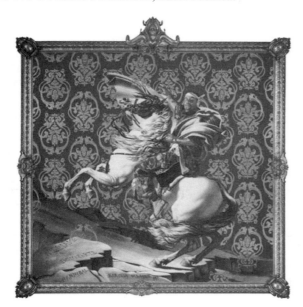

FIG. 26-09 KEHINDE WILEY, *Napoleon Leading the Army over the Alps,* 2005. Oil on canvas, 9′ × 9′. Brooklyn Museum, Brooklyn (Collection of Suzi and Andrew B. Cohen).

259

FIG. 26-09A PIULA, *Ta Tele,* 1988.

FIG. 26-10 CHRIS OFILI, *The Holy Virgin Mary,* 1996. Paper collage, oil paint, glitter, polyester resin, map pins, elephant dung on linen, 7′ 11″ × 5′ 5/16″. Victoria Miro Gallery, London.

FIG. 26-11 CLIFF WHITING (TE WHANAU-A-APANUI), *Tawhiri-Matea (God of the Winds),* 1984. Oil on wood and fiberboard, 6′ 4 3/8″ × 11′ 10 3/4″. Meteorological Service of New Zealand, Wellington.

FIG. 26-12 WILLIE BESTER, *Homage to Steve Biko,*
1992. Mixed media, 3′ 7 5/6″ × 3′ 7 5/6″. Collection of
the artist.

FIG. 26-13 DAVID HAMMONS, *Public Enemy,* installation
at Museum of Modern Art, New York, 1991. Photographs,
balloons, sandbags, guns, and other mixed media.

FIG. 26-14 LEON GOLUB, *Mercenaries IV,* 1980.
Acrylic on linen, 10′ × 19′ 2″. © Estate of Leon
Golub/Licensed by VAGA, New York, NY. Courtesy
Ronald Feldman Gallery.

FIG. 26-15 Shirin Neshat, *Allegiance and Wakefulness,* 1994. Offset print. Israel Museum, Jerusalem.

FIG. 26-16 Krzysztof Wodiczko, *The Homeless Projection,* 1986. Outdoor slide projection at the Civil War Soldiers and Sailors Monument, Boston.

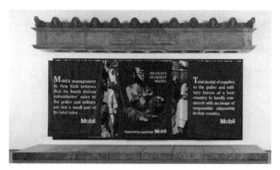

FIG. 26-17 HANS HAACKE, *MetroMobiltan,* 1985. Fiberglass construction, three banners, and photomural, 11′ 8″ × 20′ × 5′. Musée National d′Art Moderne, Centre Georges Pompidou, Paris.

FIG. 26-18 XU BING, *A Book from the Sky,* 1987. Installation at Chazen Museum of Art, University of Wisconsin, Madison, 1991. Moveable-type prints and books.

FIG. 26-19 EDWARD BURTYNSKY, *Densified Scrap Metal #3a, Hamilton, Ontario,* 1997. Dye coupler print, 2′ 2 ¾″ × 2′ 10 3/8″. National Gallery of Canada, Ottawa (gift of the artist, 1998).

FIG. 26-20 JULIAN SCHNABEL, *The Walk Home,*
1984–1985. Oil, plates, copper, bronze, fiberglass, and
Bondo on wood, 9′ 3″ × 19′ 4″. Broad Art Foundation
and the Pace Gallery, New York.

FIG. 26-21 ANSELM KIEFER, *Nigredo,* 1984. Oil paint
on photosensitized fabric, acrylic emulsion, straw,
shellac, relief paint on paper pulled from painted wood,
11′ × 18′. Philadelphia Museum of Art, Philadelphia
(gift of Friends of the Philadelphia Museum of Art).

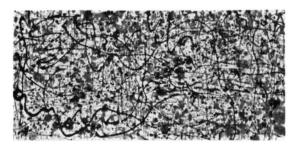

FIG. 26-22 WU GUANZHONG, *Wild Vines with Flowers
Like Pearls,* 1997. Ink on paper, 2′ 11 1/2′″ × 5′ 11″.
Singapore Art Museum, Singapore (donation from Wu
Guanzhong).

FIG. 26-22A SONG, *Summer Trees,* 1983.

FIG. 26-22B KNGWARREYE, *Untitled,* 1992.

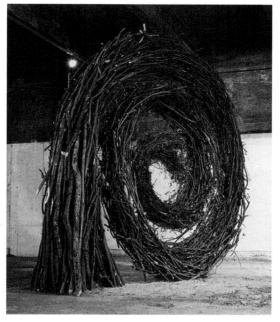

FIG. 26-23 KIMIO TSUCHIYA, *Symptom,* 1987.
Branches, 13′ 1 1/2″ × 14′ 9 1/8″ × 3′ 11 1/4″.
Installation at the exhibition *Jeune Sculpture '87,* Paris
1987.

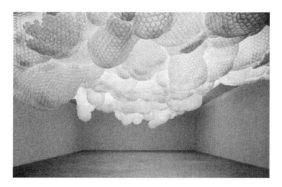

FIG. 26-24 TARA DONOVAN, *Untitled,* 2003. Styrofoam
cups and hot glue, variable dimensions. Installation at
the Ace Gallery, Los Angeles, 2005.

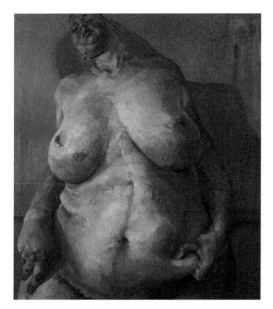

FIG. 26-25 JENNY SAVILLE, *Branded,* 1992. Oil on canvas, 7′ × 6′. Charles Saatchi Collection, London.

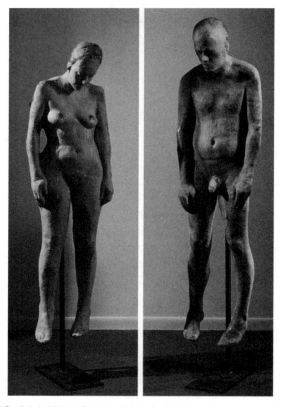

FIG. 26-26 KIKI SMITH, *Untitled,* 1990. Beeswax and microcrystalline wax figures on metal stands, female figure installed height 6′ 1 ½″ and male figure installed height 6′ 5″. Whitney Museum of American Art, New York (purchased with funds from the Painting and Sculpture Committee).

FIG. 26-27 JEFF KOONS, *Pink Panther,* 1998. Porcelain, 3′ 5″ high. Museum of Contemporary Art, Chicago (Gerald S. Elliot Collection).

FIG. 26-27A ARNESON, *California Artist,* 1982.

FIG. 26-28 MARISOL ESCOBAR, *Self-Portrait Looking at the Last Supper,* 1982–1984. Painted wood, stone, plaster, and aluminum, 10′ 1 ½″ × 29′ 10″ × 5′ 1″. Metropolitan Museum of Art, New York (gift of Mr. and Mrs. Roberto C. Polo, 1986).

FIG. 26-28A TANSEY, *A Short History of Modernist Painting,* 1982.

FIG. 26-29 PAA JOE, running shoe, airplane, automobile and other coffins inside the artist's showroom in Teshi, Ghana, 2000. Painted wood.

FIG. 26-30 NORMAN FOSTER, Hong Kong and Shanghai Bank (looking southwest), Hong Kong, China, 1979–1986.

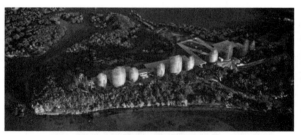

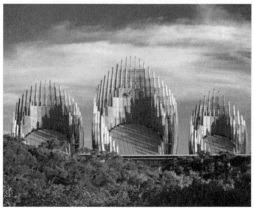

FIG. 26-31 RENZO PIANO, aerial view (*top;* looking northwest) and three "huts" (*bottom;* looking southeast), Tjibaou Cultural Centre, Noumea, New Caledonia, 1998.

FIG. 26-32 Günter Behnisch, Hysolar Institute (looking north), University of Stuttgart, Stuttgart, Germany, 1987.

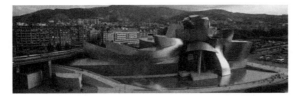

FIG. 26-33 Frank Gehry, Guggenheim Bilbao Museo (looking south), Bilbao, Spain, 1997.

FIG. 26-34 Frank Gehry, atrium of the Guggenheim Bilbao Museo, Bilbao, Spain, 1997.

FIG. 26-34A STIRLING, Neue Staatsgalerie, Stuttgart, 1977–1983.

FIG. 26-34B LIBESKIND, Denver Art Museum, 2006.

FIG. 26-35 ZAHA HADID, Vitra Fire Station (looking east), Weil-am-Rhein, Germany, 1989–1993.

FIG. 26-36 IEOH MING PEI, Grand Louvre Pyramide (looking southwest), Musée du Louvre, Paris, France, 1988.

FIG. 26-37 MAYA YING LIN, Vietnam Veterans Memorial (looking north), Washington, D.C., 1981–1983.

FIG. 26-38 RACHEL WHITEREAD, Holocaust Memorial (looking northwest), Judenplatz, Vienna, Austria, 2000.

FIG. 26-39 RICHARD SERRA, *Tilted Arc,* Jacob K. Javits Federal Plaza, New York City, 1981.

FIG. 26-40 CHRISTO and JEANNE-CLAUDE, *Surrounded Islands, Biscayne Bay, Miami, Florida, 1980–1983.*

FIG. 26-41 ANDY GOLDSWORTHY, *Cracked Rock Spiral,* St. Abbs, Scotland, 1985.

FIG. 26-42 KEITH HARING, *Tuttomondo,* Sant'Antonio (looking south), Pisa, Italy, 1989.

FIG. 26-43 ANDREAS GURSKY, *Chicago Board of Trade II,* 1999. C-print, 6′ 9 1/2″ × 11′ 5 5/8″. Matthew Marks Gallery, New York.

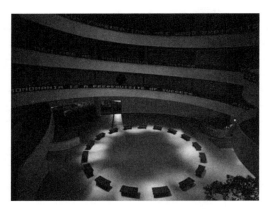

FIG. 26-44 Jenny Holzer, *Untitled* (selections from *Truisms, Inflammatory Essays, The Living Series, The Survival Series, Under a Rock, Laments,* and *Child Text*), 1989. Extended helical tricolor LED electronic display signboard, 16′ × 162′ × 6′. Installation at the Solomon R. Guggenheim Museum, New York, December 1989–February 1990 (partial gift of the artist, 1989).

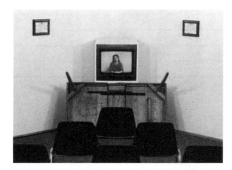

FIG. 26-45 Adrian Piper, *Cornered,* 1988. Mixed-media installation of variable size; video monitor, table, and birth certificates. Museum of Contemporary Art, Chicago.

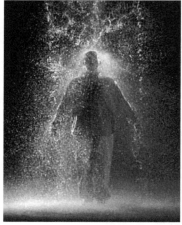

FIG. 26-46 Bill Voila, *The Crossing,* 1996. Video/sound installation with two channels of color video projection onto screens 16′ high.

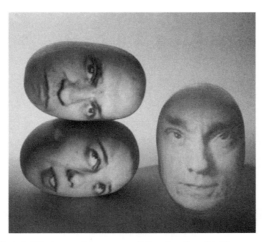

FIG. 26-47 TONY OURSLER, *Mansheshe,* 1997.
Ceramic, glass, video player, videocassette, CPJ-200
video projector, sound 11″ × 7″ × 8″ each. Courtesy of
the artist and Metro Pictures, New York.

FIG. 26-48 MATTHEW BARNEY, *Cremaster* cycle,
installation at the Solomon R. Guggenheim Museum,
New York, 2003.

